Copyright 2017 Textile Study Group of New York, Inc.

ISBN 978-1548923020

All rights reserved

Textile Study Group of New York
http://tsgny.org
info@tsgny.org

PO BOX 3592, Grand Central Station, New York, NY 10163

Published by thesohobookie.com

Cover image; detail, Extension/Velocity by Elaine Longtemps

CROSSING LINES

The Many Faces of Fiber

December 6, 2011 — April 1, 2012

World Financial Center Courtyard Gallery
Three World Financial Center, New York City

Sponsored by the Textile Study Group of New York

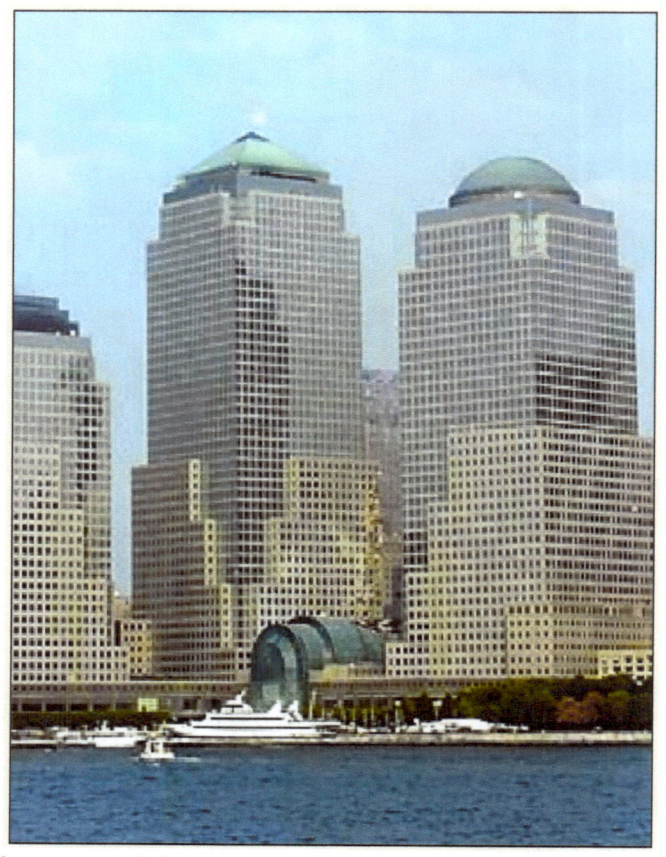

Hudson River waterfront view of the World Financial Center's complex of buildings in lower Manhattan.

CROSSING LINES: The Many Faces of Fiber
opened at the Courtyard Gallery of the World Financial Center
on December 6, 2011 and closed on April 12, 2012
During that time, the gallery was open
Tuesday through Sunday from 12:00 noon to 4:00 pm.

5,445 visitors viewed the exhibition

CROSSING LINES: The Many Faces of Fiber

This exhibition, sponsored by the Textile Study Group of New York (TSGNY), highlights the dynamic diversity of contemporary fiber. These artists, who explore the flexible attributes of this versatile medium, weave, stitch, knot, and employ other structural techniques to make two and three-dimensional works of limitless shape, size, and aesthetic. They have adopted and adapted traditional textile genres, exploring fibers as a powerful, expressive medium. They also investigate the formal properties of fiber—line, color, texture—and use them to comment on art, life, and the human condition.

The exhibition, juried by Rebecca A. K. Stevens, is presented in celebration of the 35th anniversary of the Textile Study Group of New York (TSGNY). Rebecca A. K. Stevens is consulting curator of Contemporary Textiles at The Textile Museum, Washington, DC and is also the author of numerous articles on contemporary American textiles, exhibition catalogs, and two books: "The Kimono Inspiration: Art and Art-to-Wear in America" (with Yoshiko Wada and Ed Rossbach), and "40 Years of Innovation and Exploration in Fiber Art" (with Ann Rowe). She has extensive national and international experience as lecturer, consultant, and juror.

TSGNY, founded in 1975, is a non-profit organization of artists, critics, and museum professionals who meet monthly to discuss a broad survey of fiber art styles, concepts, and materialization - the many faces of fiber. The organization is dedicated to promoting the fiber arts and the diverse professional activities, disciplines, and media that coalesce to bring vitality and excitement to the world of fiber art today.

It is with profound gratitude that we acknowledge the generous support of this project by Brookfield Properties Management, American Express, and Bank of America.

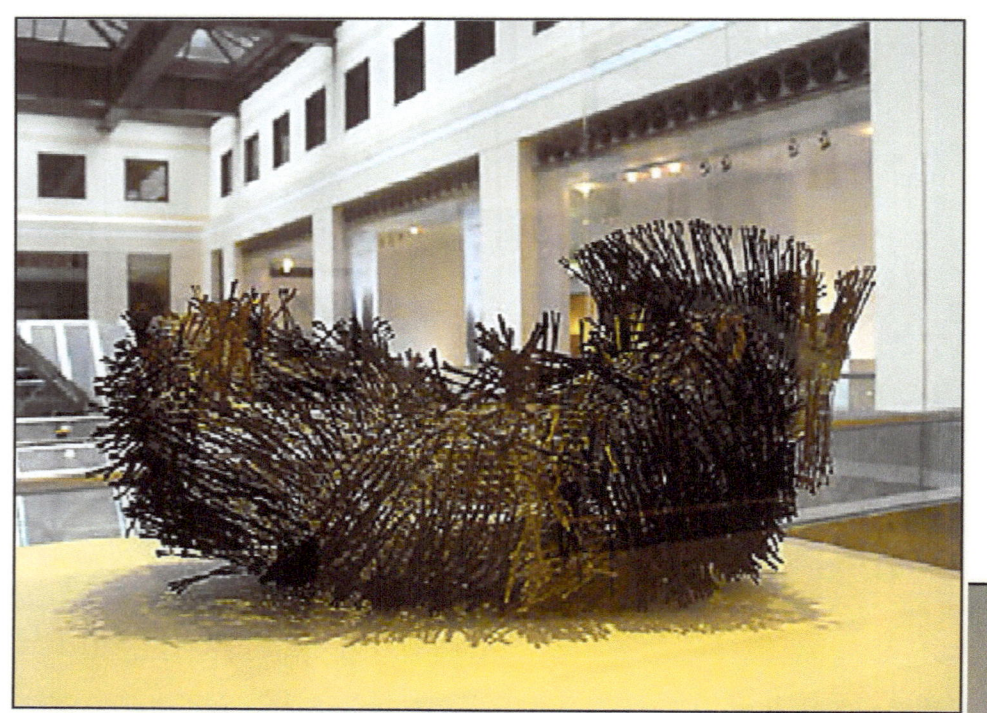
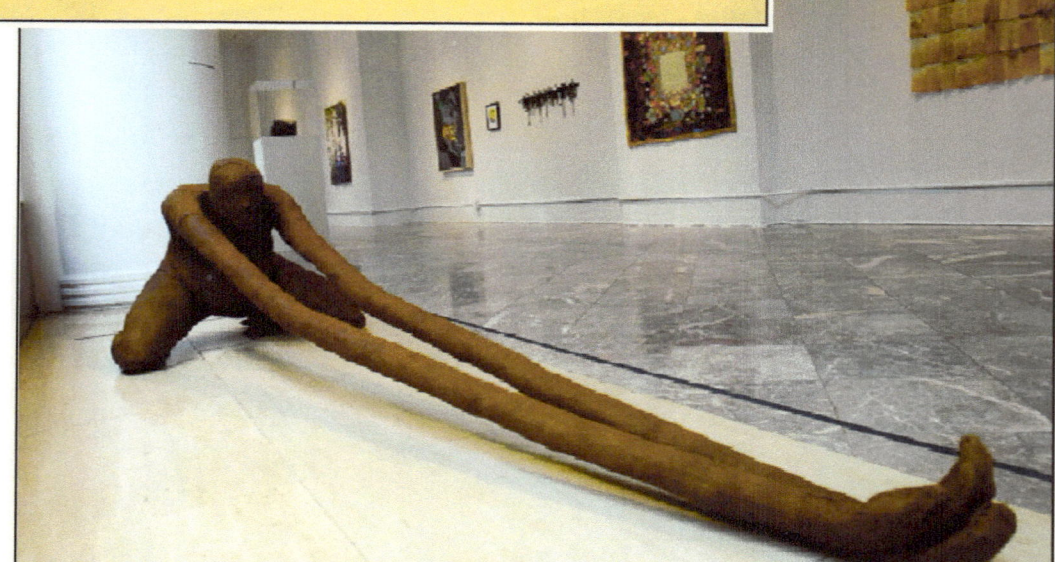

CROSSING LINES: The Many Faces of Fiber

54 artists = 57 works

Elizabeth Barton. Athens, GA	Hyunju Kim, Long Island City, NY	Joy Saville, Princeton, NJ
Polly Barton. Santa Fe, NM	Katherine Knauer, New York, NY	Linda Friedman Schmidt, Franklin Lakes, NJ
Janet Bloor, New York, NY	Nancy Koenigsberg (2), New York, NY	Larry Schulte, New York, NY
George-Ann Bowers, Berkeley, CA	Daryl Lancaster, Lincoln Park, NJ	Biba Schutz, New York, NY
Michele Brody, New York, NY	Janet Levine, New York, NY	Robin Schwalb, Brooklyn, NY
Benedicte Caneill, New York, NY	Elaine Longtemps, Brooklyn, NY	Won Ju Seo, Englewood Cliffs, NJ
Margaret Cusack, Brooklyn, NY	Susan Martin Maffei (2), New Baltimore, NY	Adrienne Sloane, Watertown, MA
Virginia Davis, Berkeley, CA	Patricia Malarcher, Englewood, NJ	Christine Spangler, Chevy Chase, MD
Emily Dvorin, Kentfield, CA	Saberah Malik, Warwick, RI	Marcy Sperry, Brooklyn, NY
Susan Edmunds, Highland Park, NJ	Barabara Maxey, Tuckahoe, NY	Ruth Tabancay, Berkeley, CA
Erin Endicott, Port Republic, NJ	Dorothy McGuinness (2), Everett, WA	Myrna Tatar, San Francisco, CA
Jayne Bentley Gaskins, Fernandina Beach, FL	Rebecca Mushtare,, Mt. Kisco, NY	Betty Vera, Woodstock, NY
Marilyn Henrion, New York, NY	Bonnie Peterson, Houghton, MI	Grace Bakst Wapner, Woodstock, NY
Pater Hiers, Pacific Beach, CA	Wen Redmond, Strafford, NH	Kathy Weaver, Chicago, IL
Eileen Hoffman, Brooklyn, NY	Linda Rettich, Bayside, NY	Ellie Winberg, Brooklyn, NY
Sabrina Hughes (2), Tampa, FL	Michael Rohde, Westlake Village, CA	Rachel C. Wright, Palo Alto, CA
Marie-Laure Ille, Redondo Beach, CA	Donna Rosenthal, New York, NY	Saaralisa Ylitalo (2), Washington, DC
Julia E. Kiechel, Dartmouth, MA	Lois Russell, Boston, MA	Bhakti Ziek, Randolph, VT

Elizabeth Barton

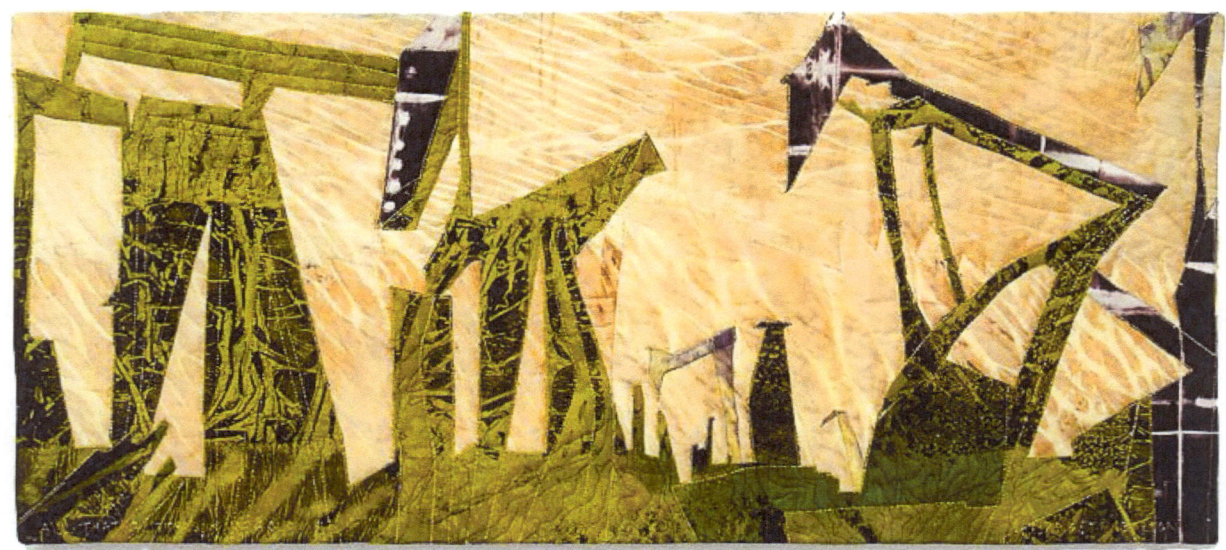

.All that Glitters. .18" x 40" x 0.125" Hand dyed and screen printed fabric, quilted.

Polly Barton

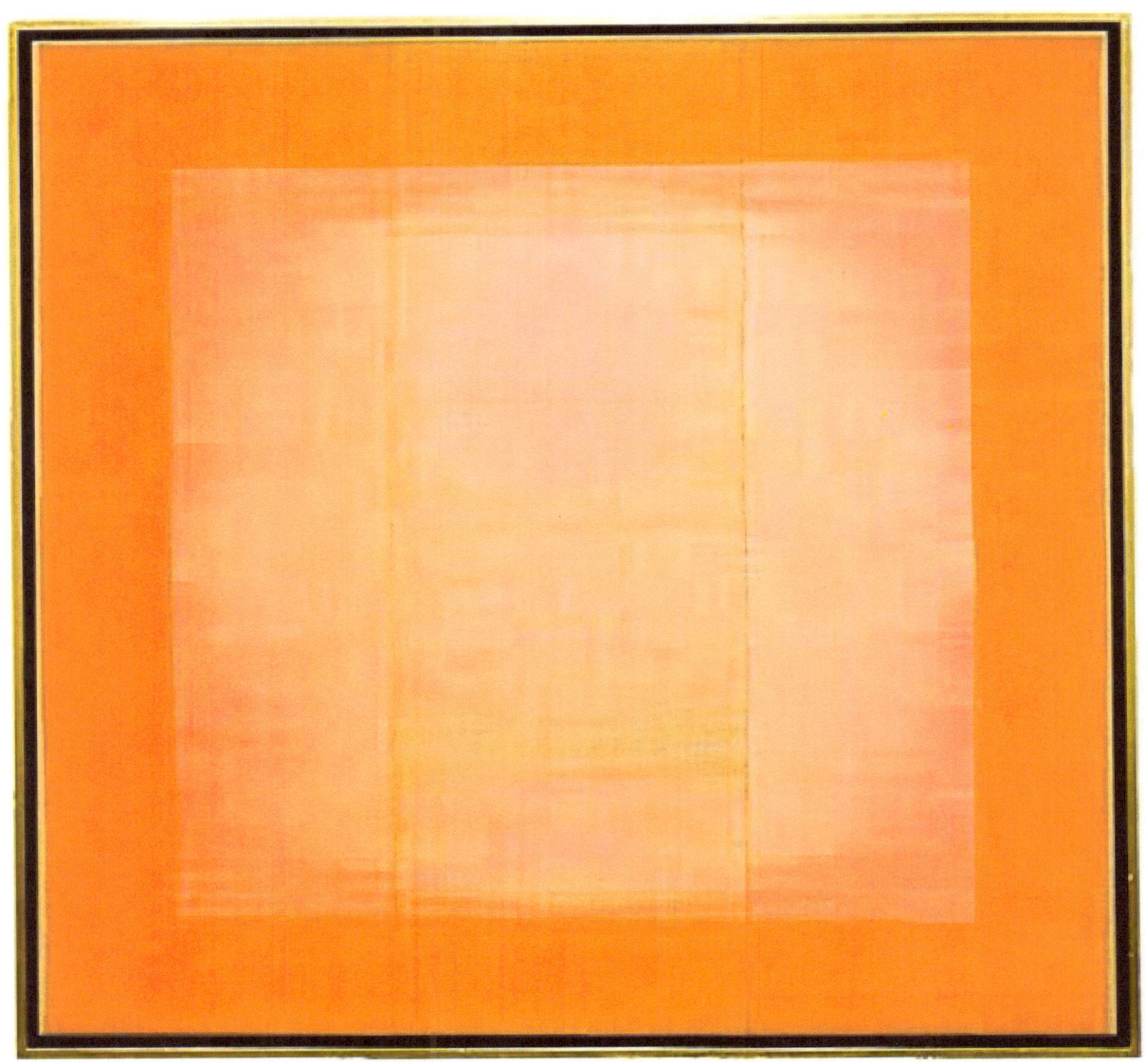

Sotto Voce 51.25″ x 53.75″ x 1.5″. Rayon warp, ikat silk weft; vermillion sumi ink.

Janet Bloor

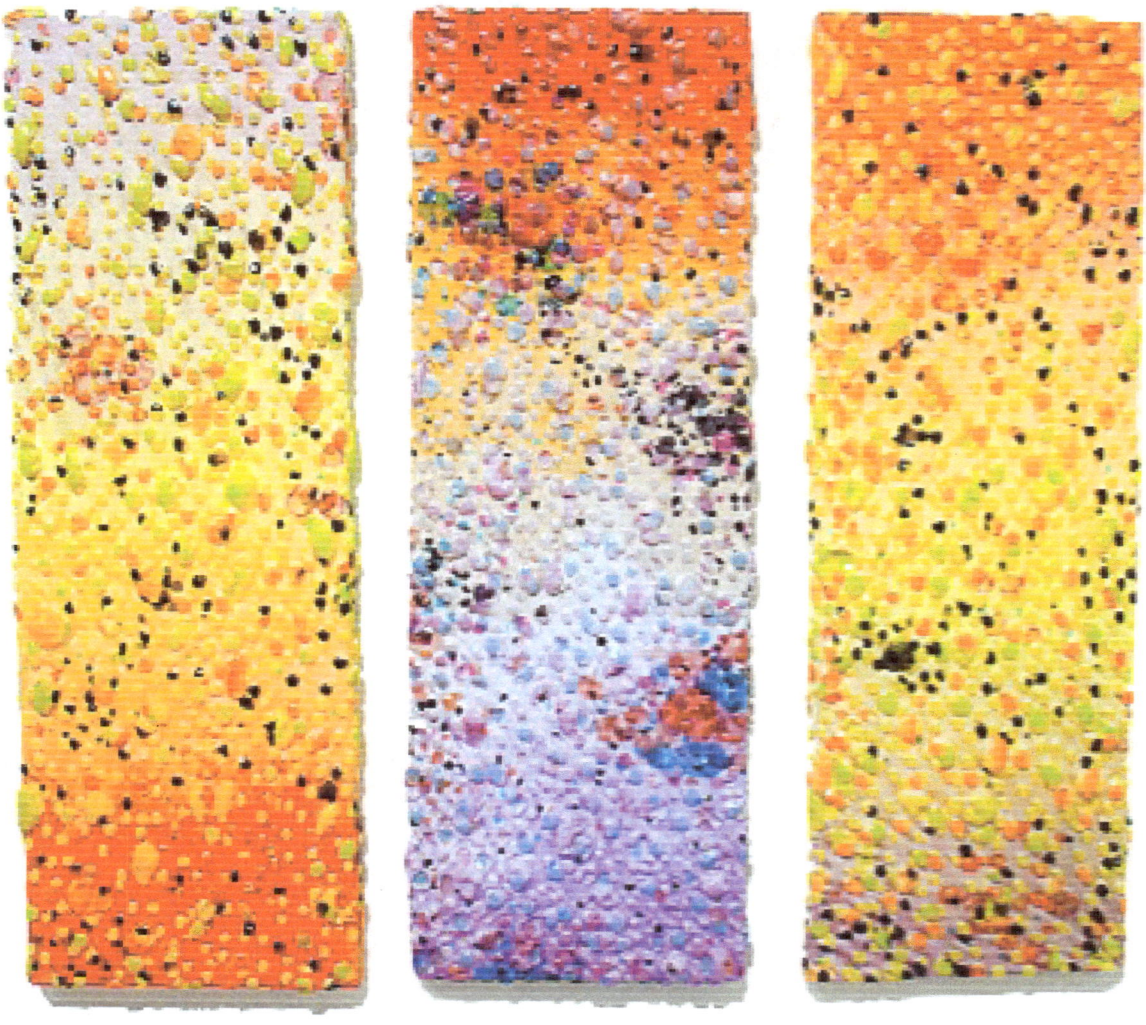

Alien Landscape. 30" x 34" x 1". Nylon, lycra, silicone; dyed, painted, textured, overdyed

George-Ann Bowers

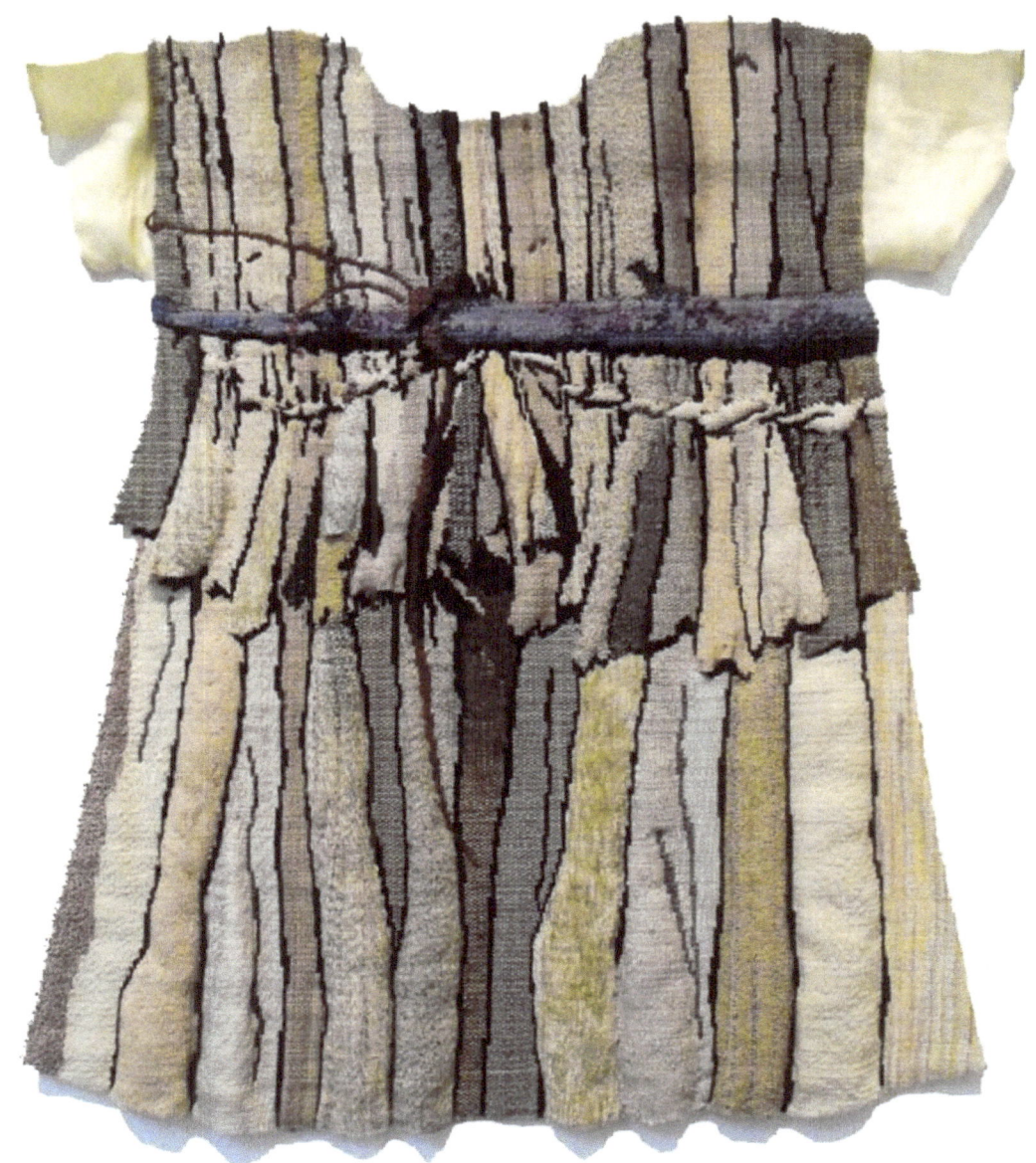

Ohlone Housecoat 36" x 33" x 2" Triple-weave pickup; cotton, wool, rayon, silk.

Michele Brody

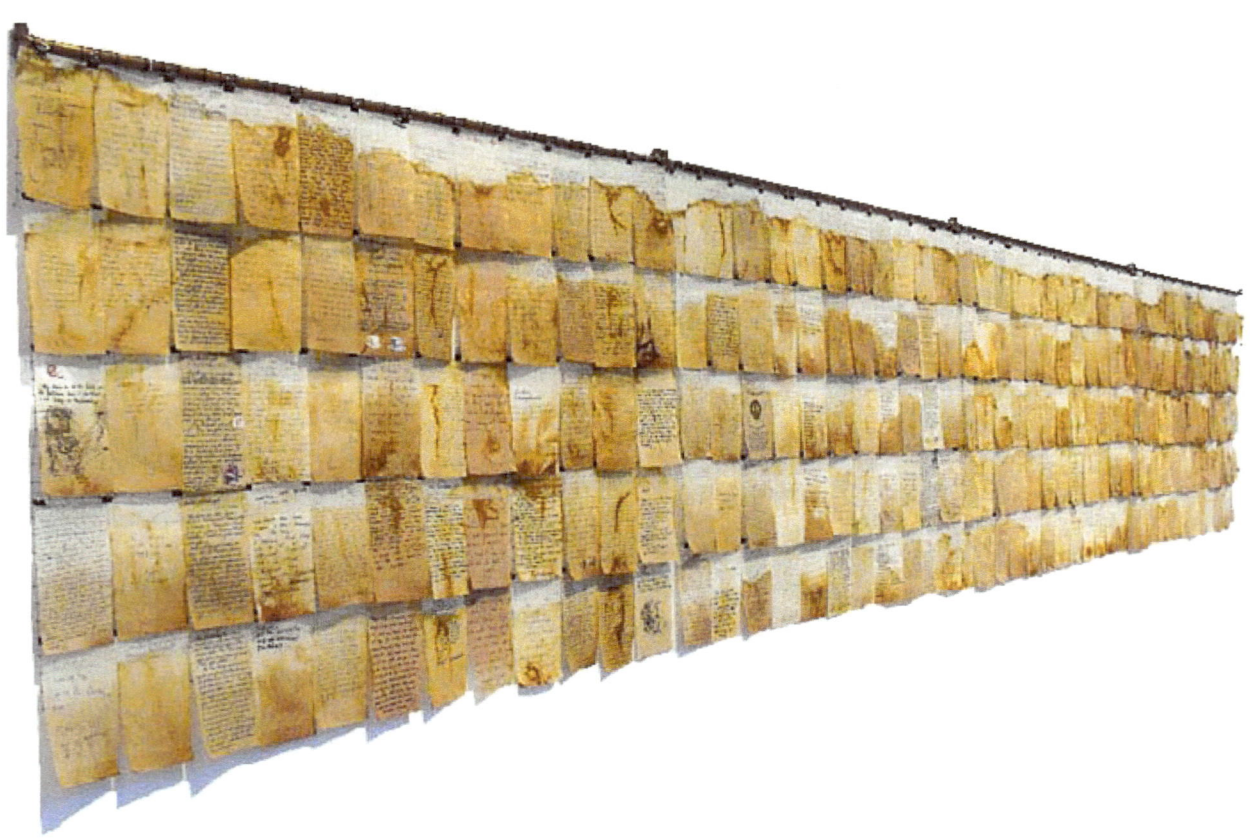

Tea Mountain Quilt. 36" x 144" x .5". Tea stained teabags clipped to netting.

Margaret Cusack

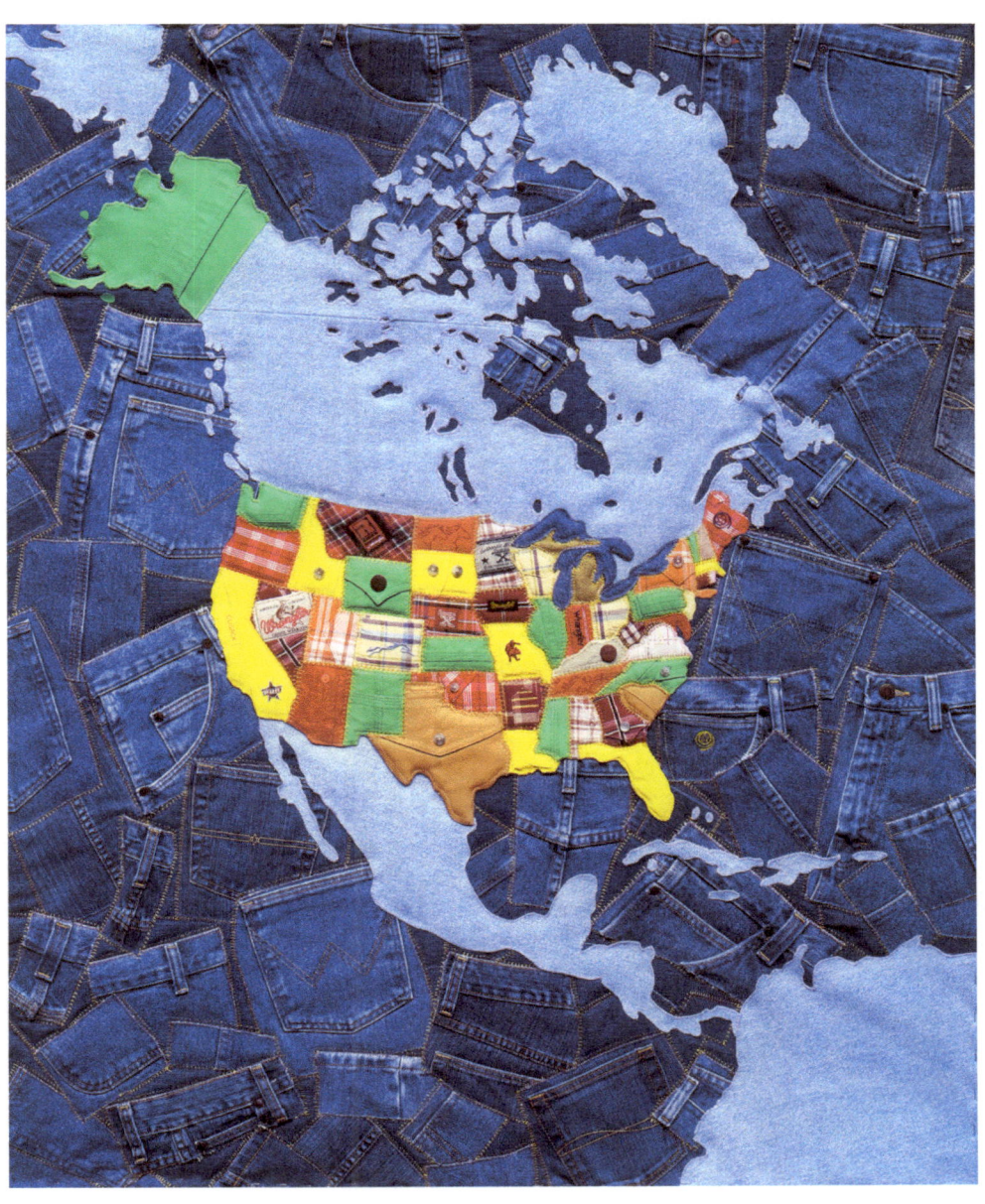

Wrangler Map 48" x 40" Machine stitched appliquéd

Benedicte Caneill

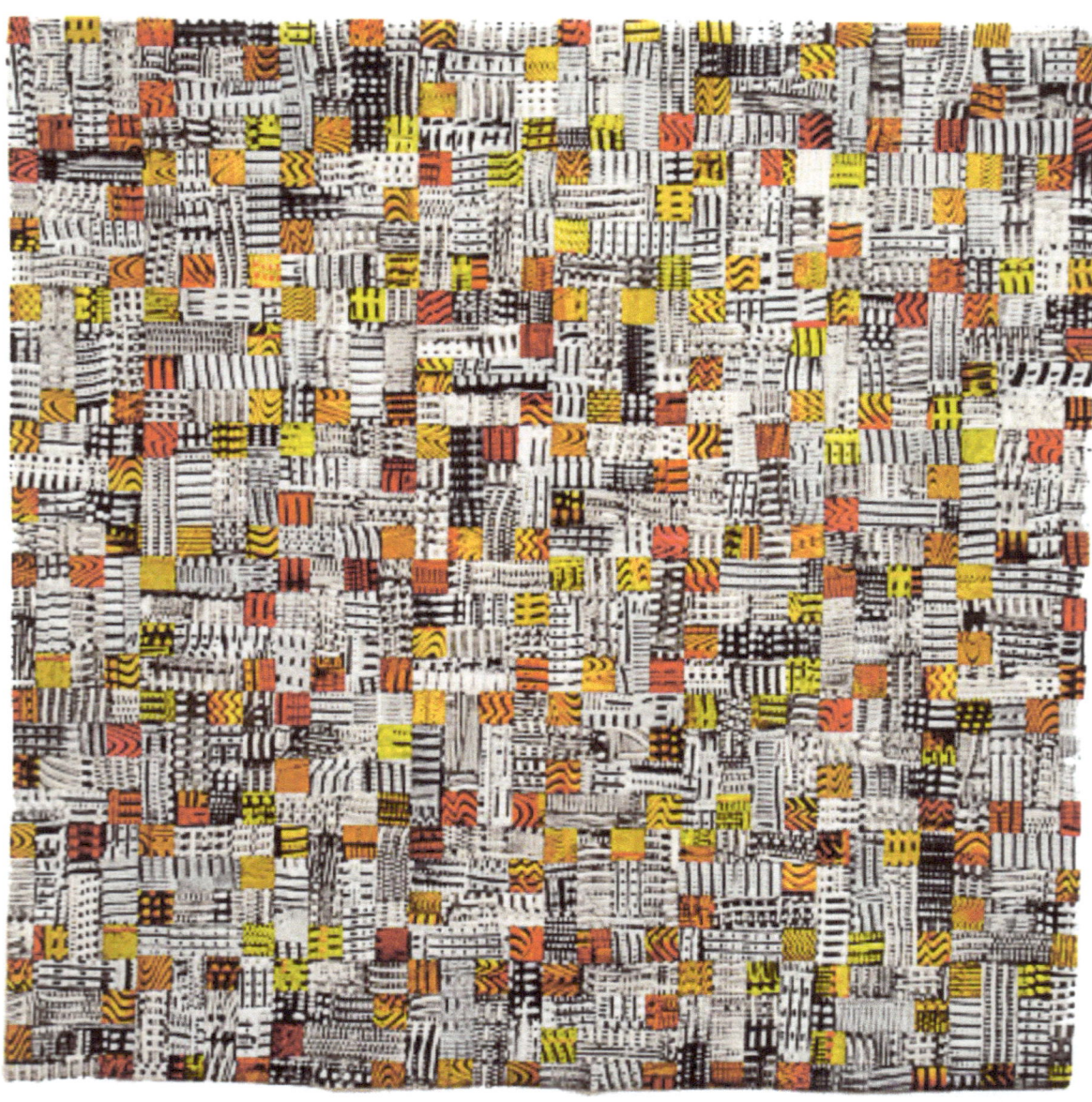

Units 2: Cityscape 46" x 46" x 0.5" Cotton fabrics monoprinted with fabric paint; machine pieced and quilted

Virginia Davis

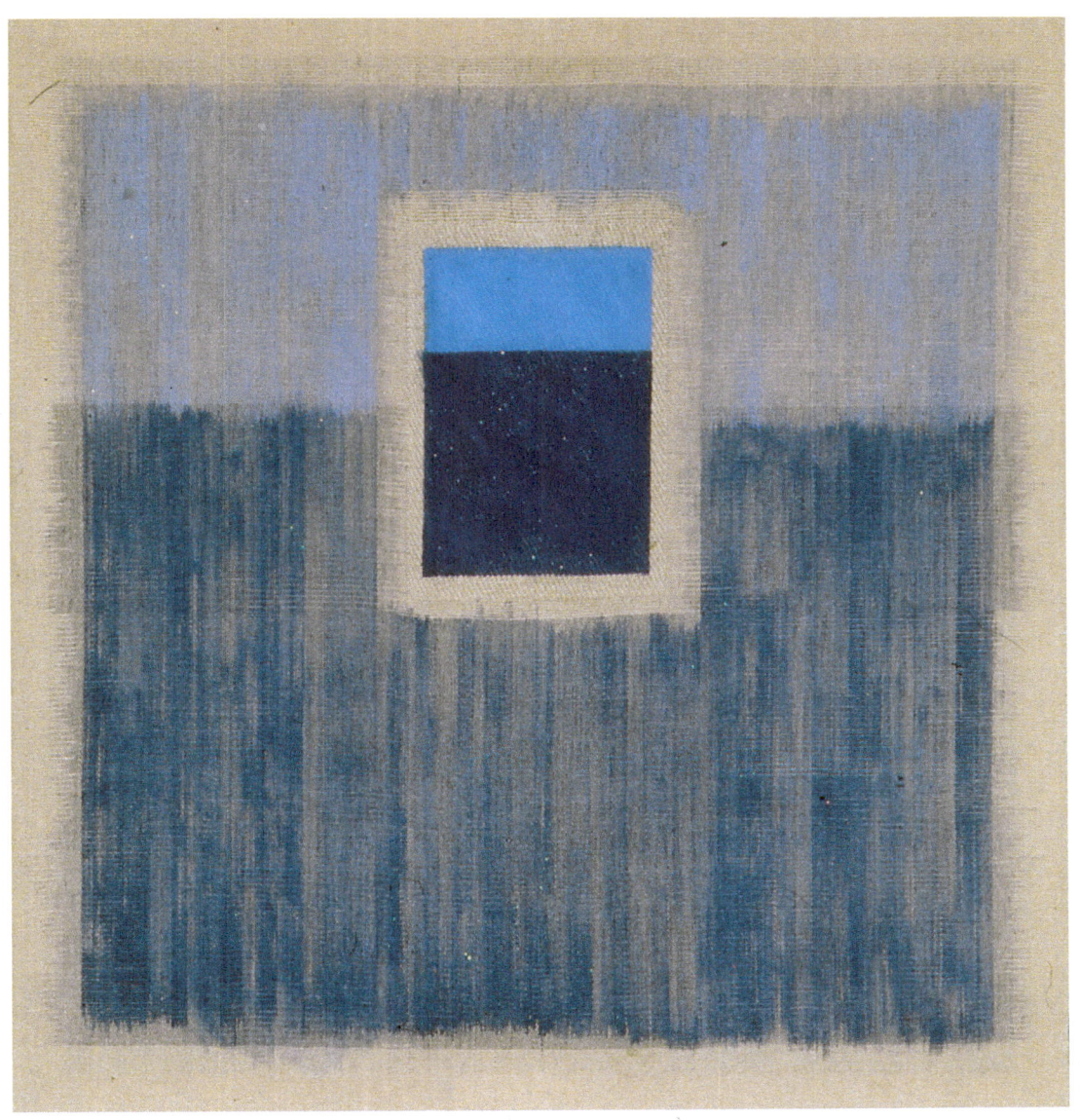

Blue 34" x 32" x 2" Acrylic in linen, ikat weaving, painting on surface.

Emily Dvorin

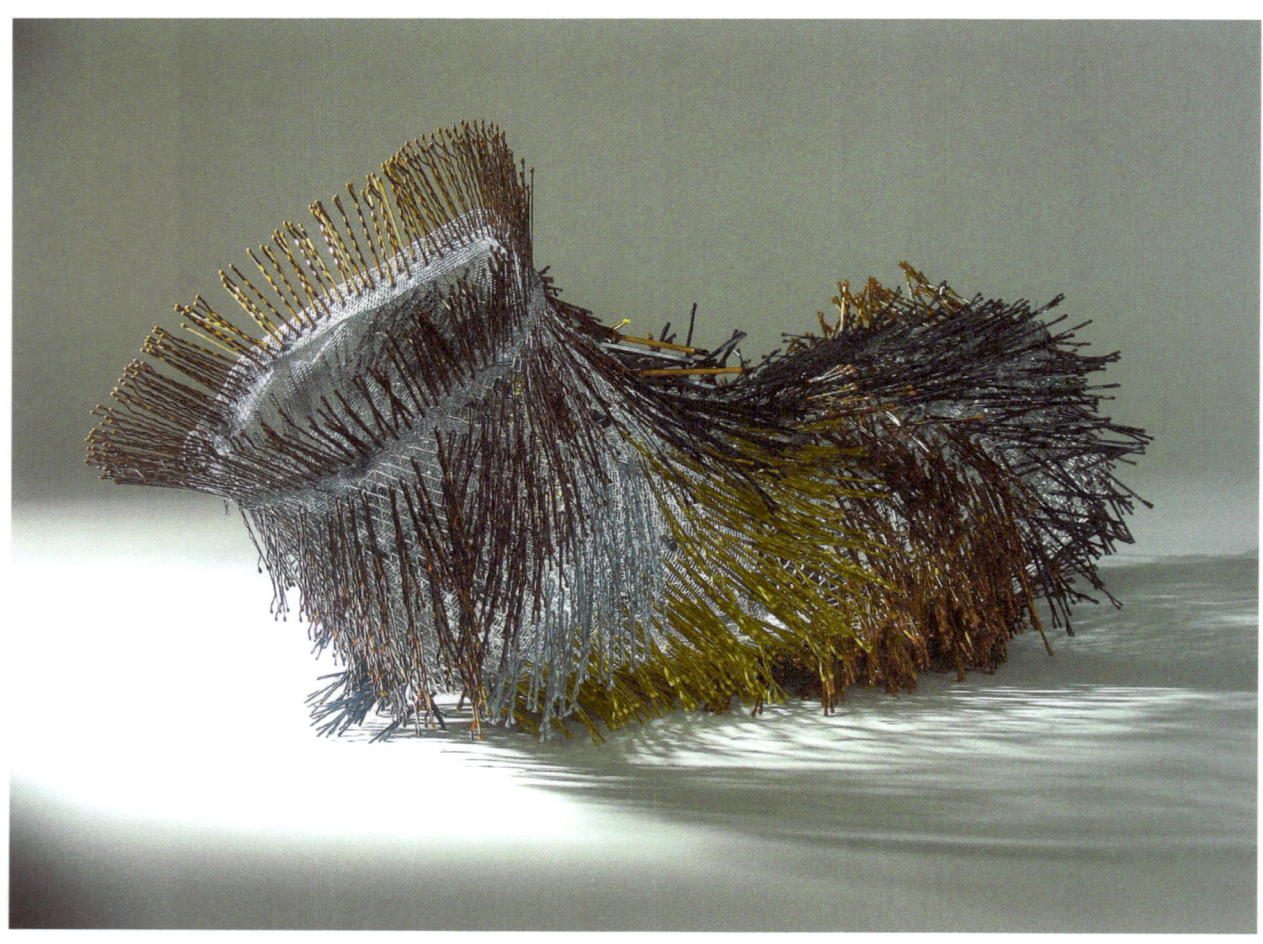

Never a Dull Moment. 11" x 21" x 12" Gutter screening, cable ties, bobby pins, florist's wire; assemblage, embroidery.

Susan Edmunds

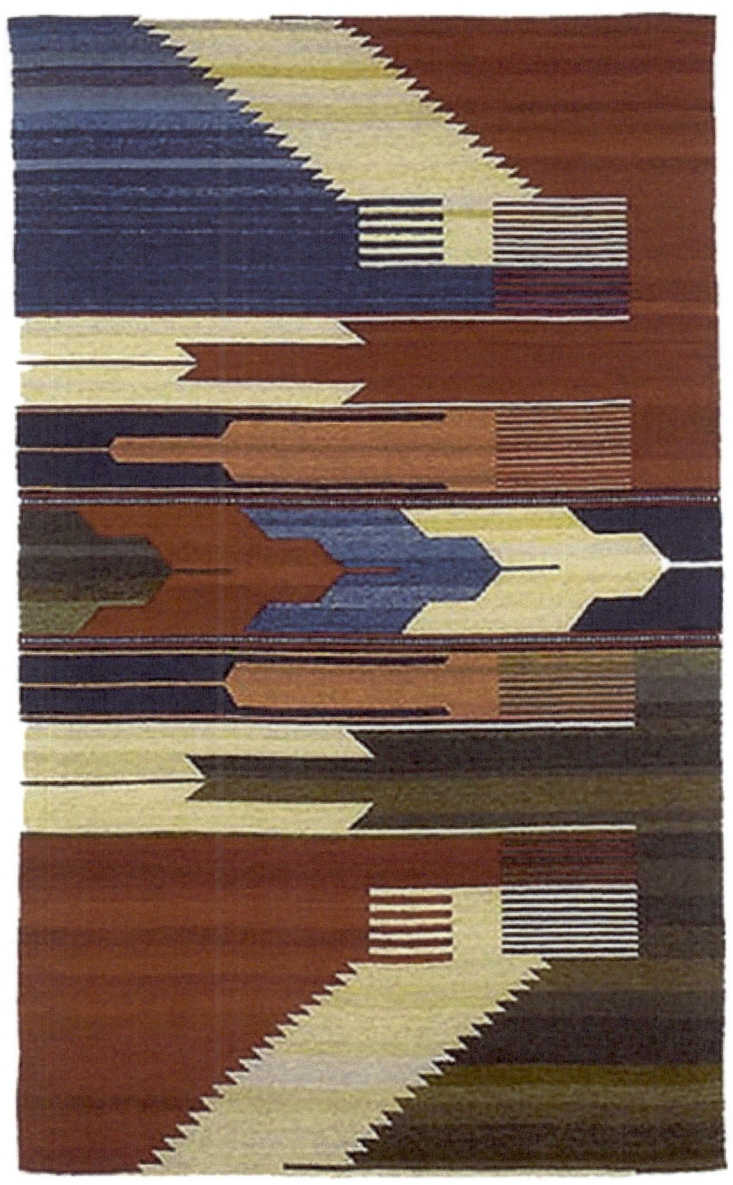

Kilim Fragment 65" x 35.5" x 0.125" Wool, plant dyes, tapestry.

Erin Endicott

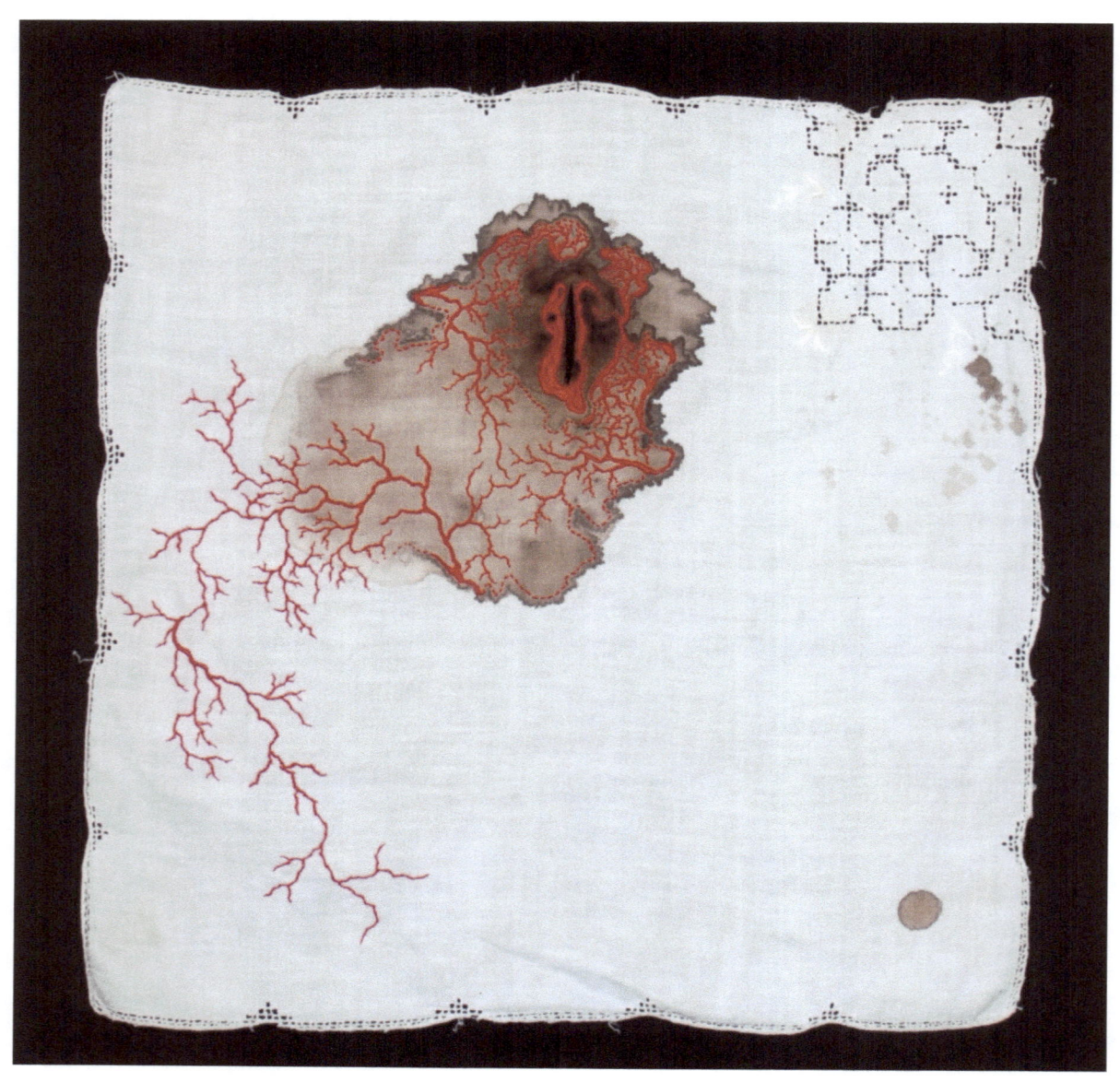

Healing Sutra #7 15" x 15" Hand embroidery and walnut ink on antique cotton napkin.

Jayne Bentley Gaskins

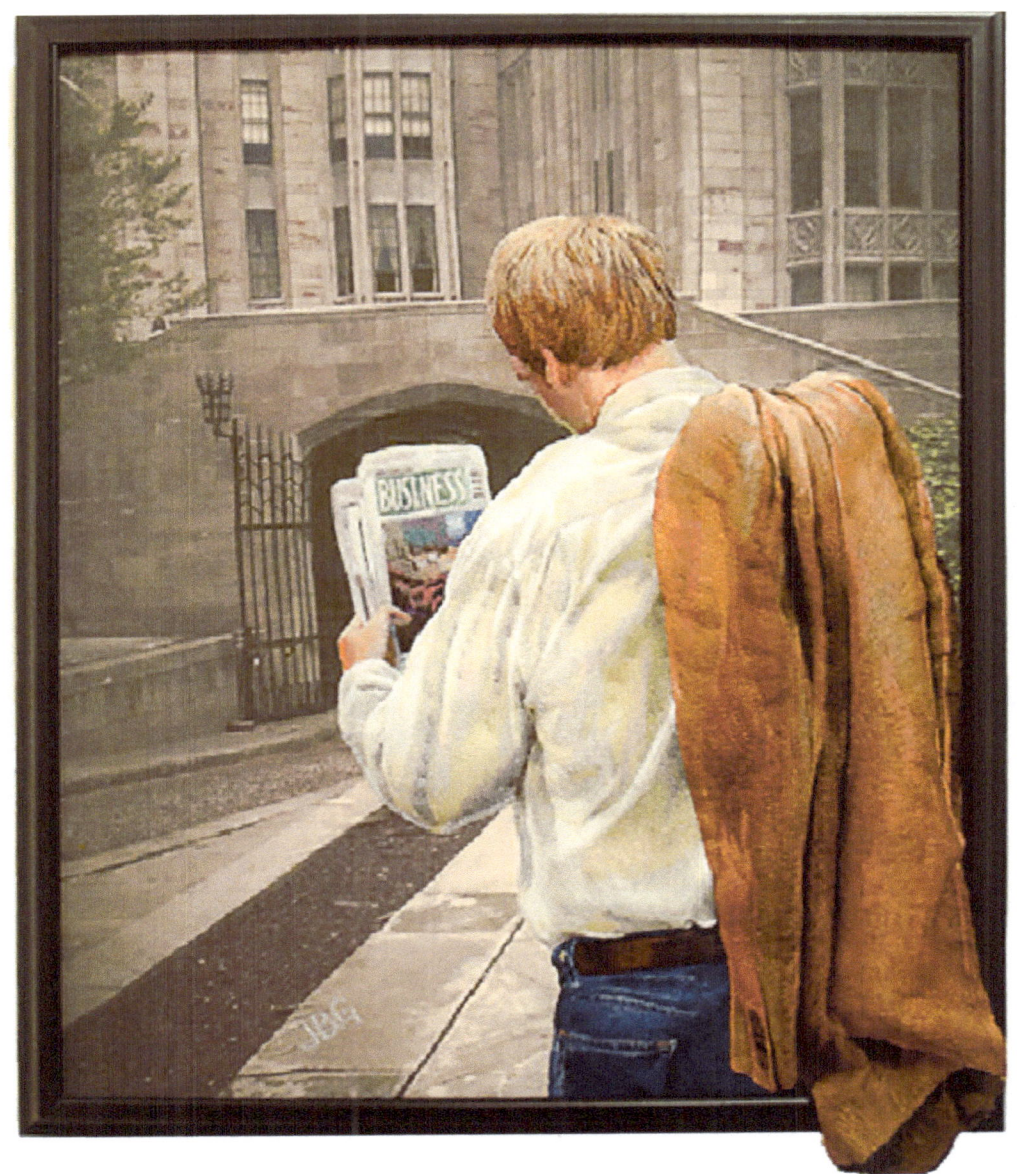

Options 32″ x 27″ x 2″ Digital photo printed on fabric, thread-painting, trapunto quilting.

Marilyn Henrion

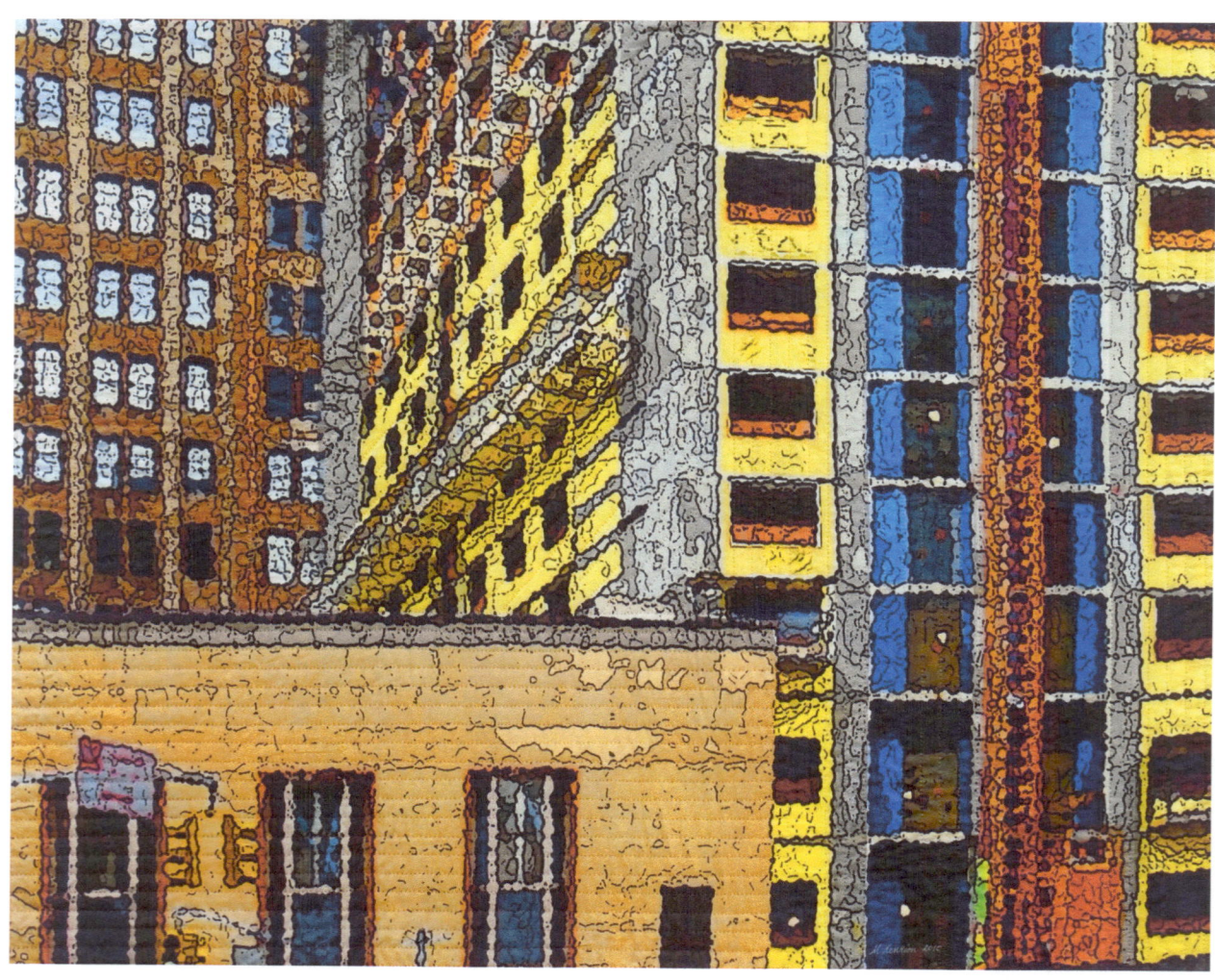

Soft City: Canal Street Construction. 40" x 50" x 0.25" Digitally manipulated photography, pigment printing on cotton, hand quilting

Peter Hiers

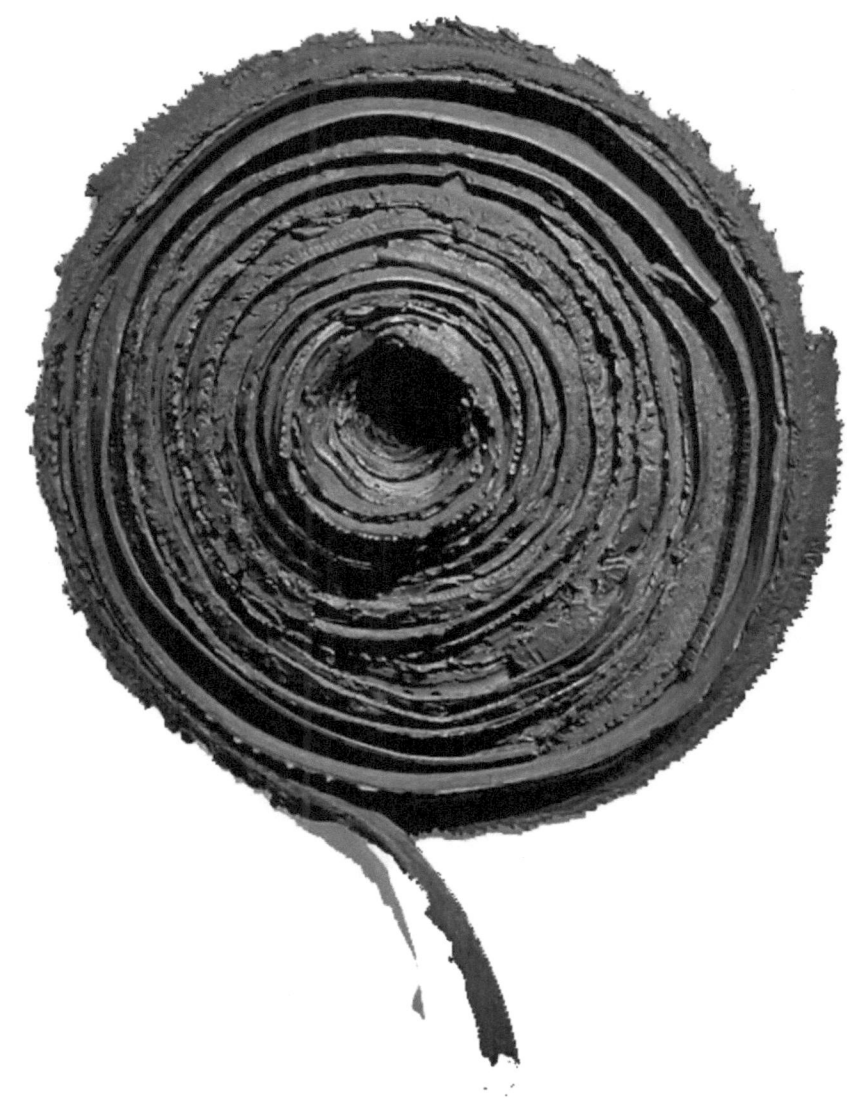

Mythology Unraveling 36″ x 45″ x 8″ Found tire rubber strips, custom mounting

Eileen Hoffman

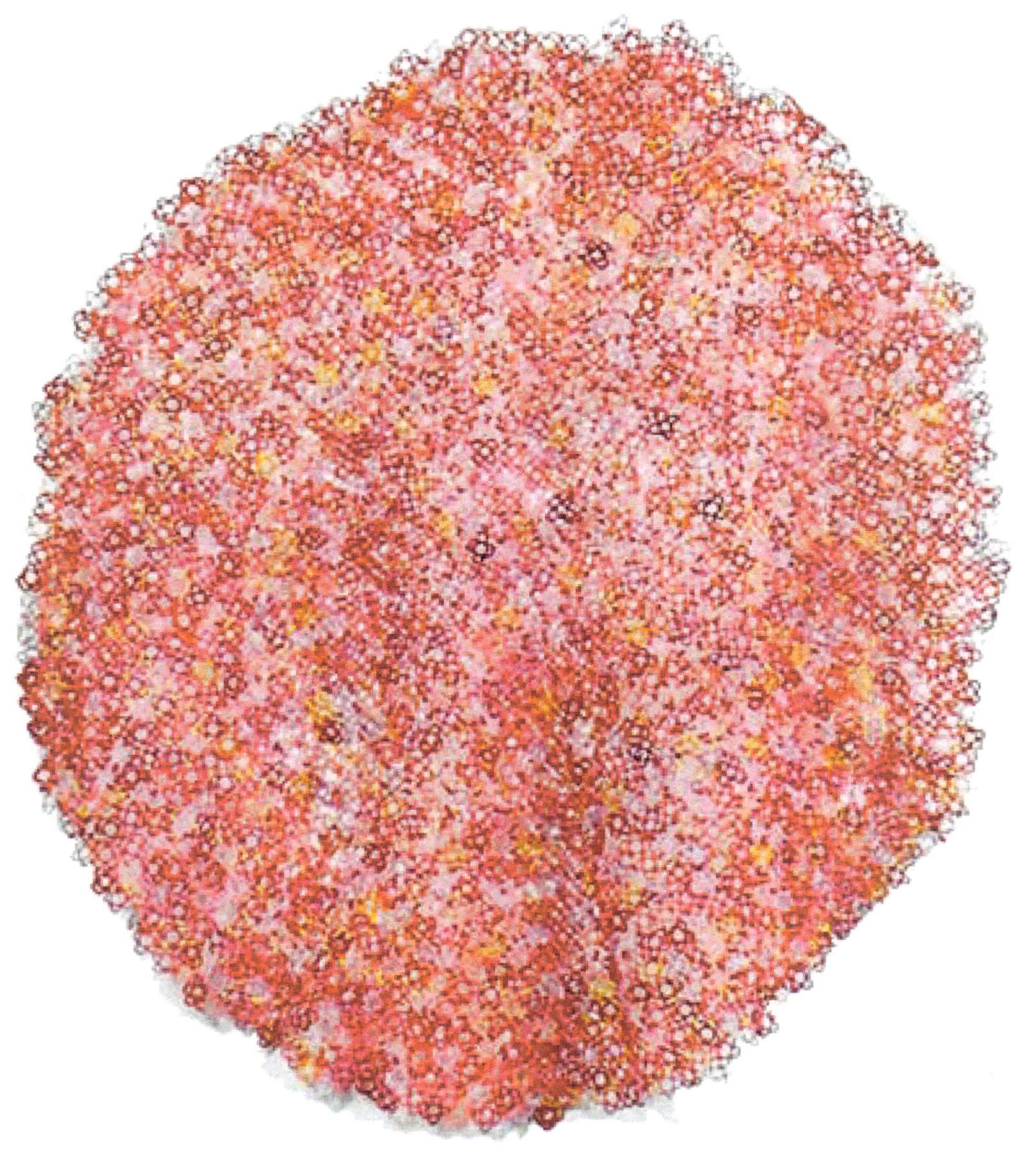

Redolence 72″ x 66″ x 3″ Chenille craft stems.

Sabrina Hughes

37856 stitches, 100 colors 12" x 8" x 1" Hand cross-stitched photograph.

Sabrina Hughes

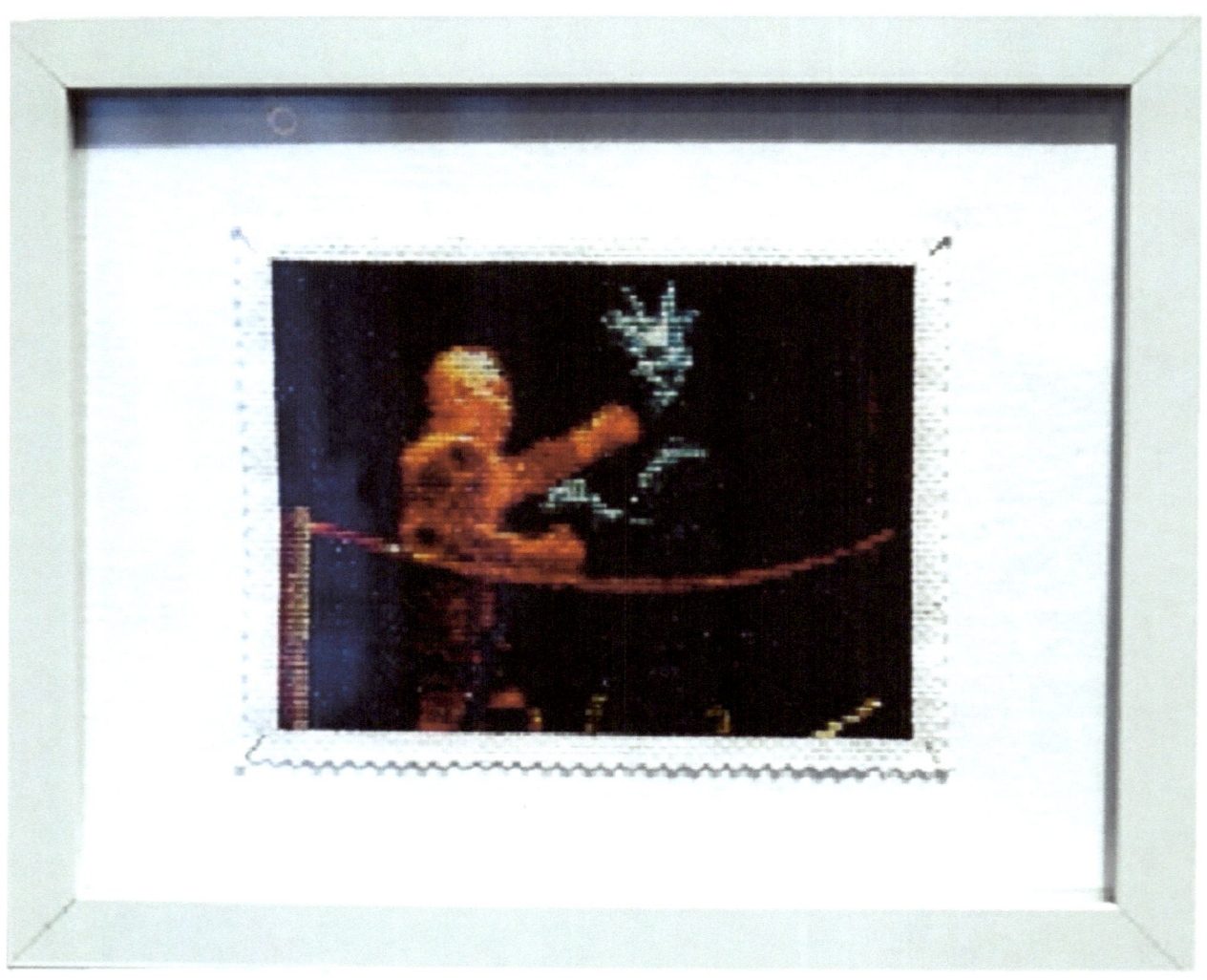

10584 stitches, 58 colors 4" x 6" x 1" Hand cross-stitched photograph.

Marie-Laure Ilie

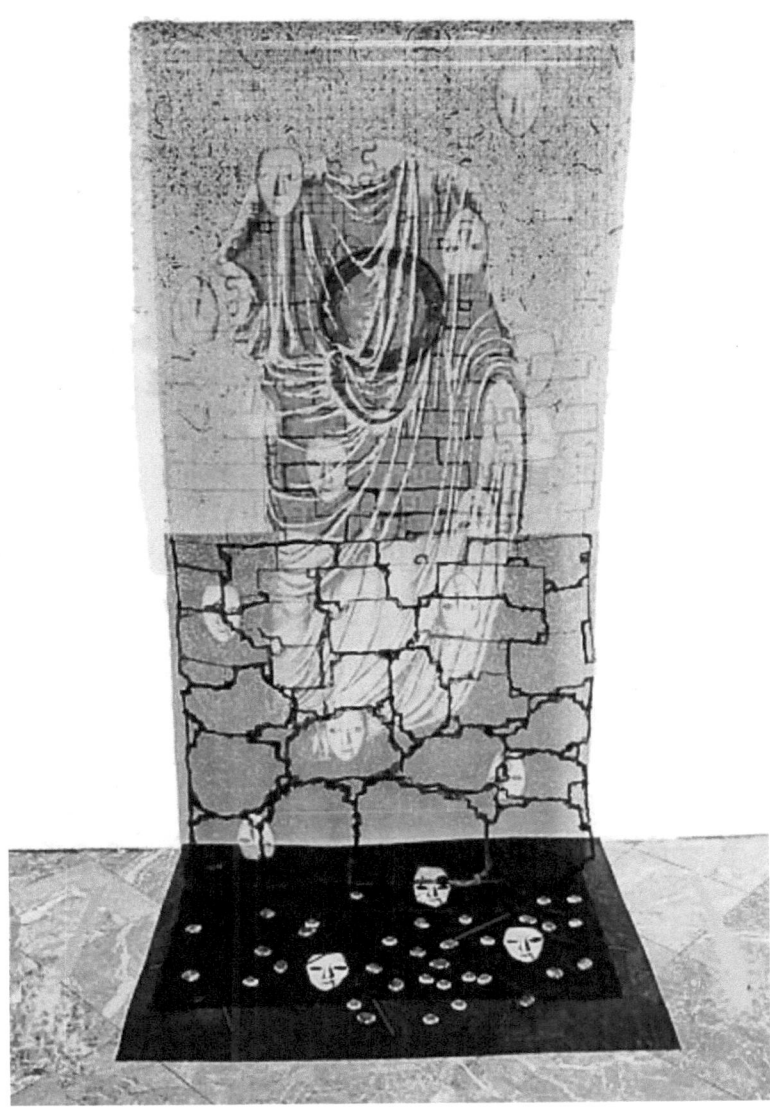

Sic Transit Gloria Mundi 85" x 48" x 30" Organza, plastic mesh, mixed media; painting, heat transfers.

Julia E. Keichel

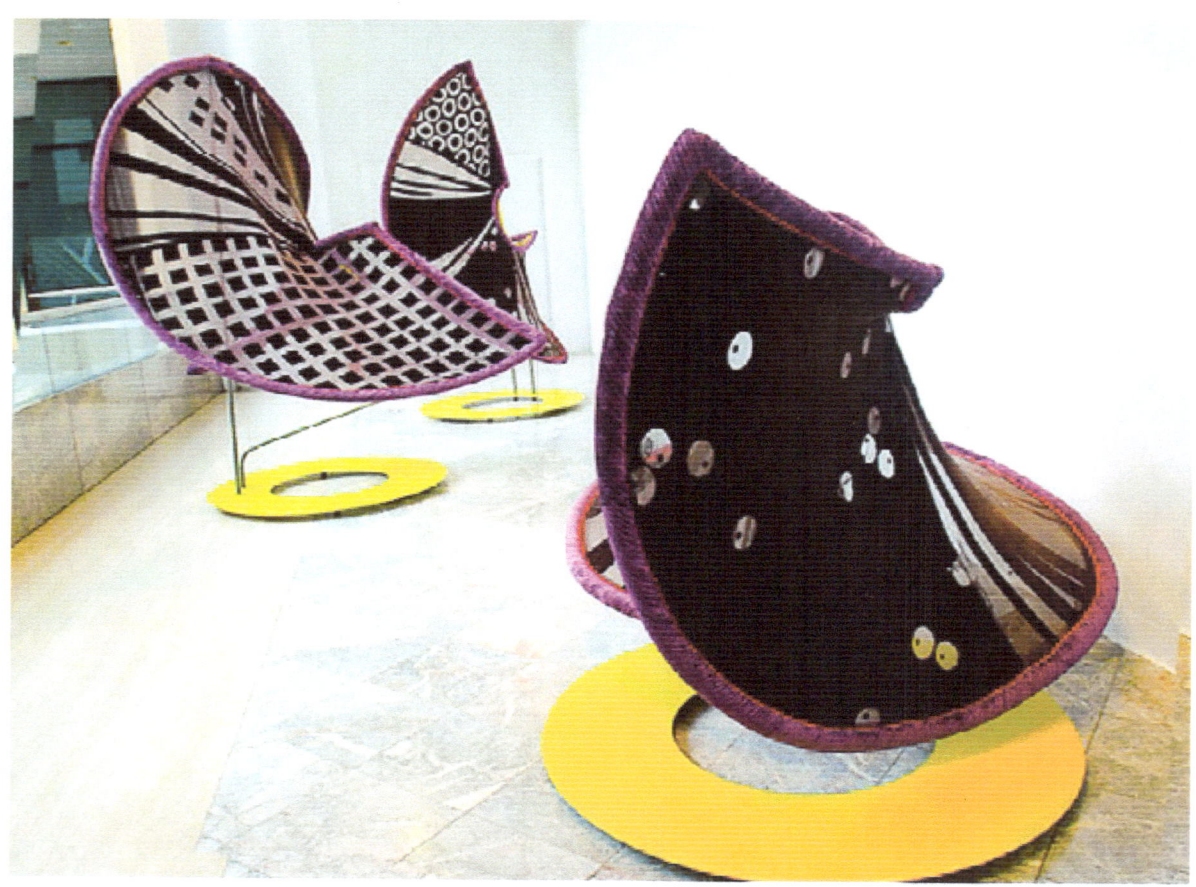

Performance 7' 6" x 6' x 12' Silk, rayon, polyester, steel, foam, Devore

Hyunju Kim

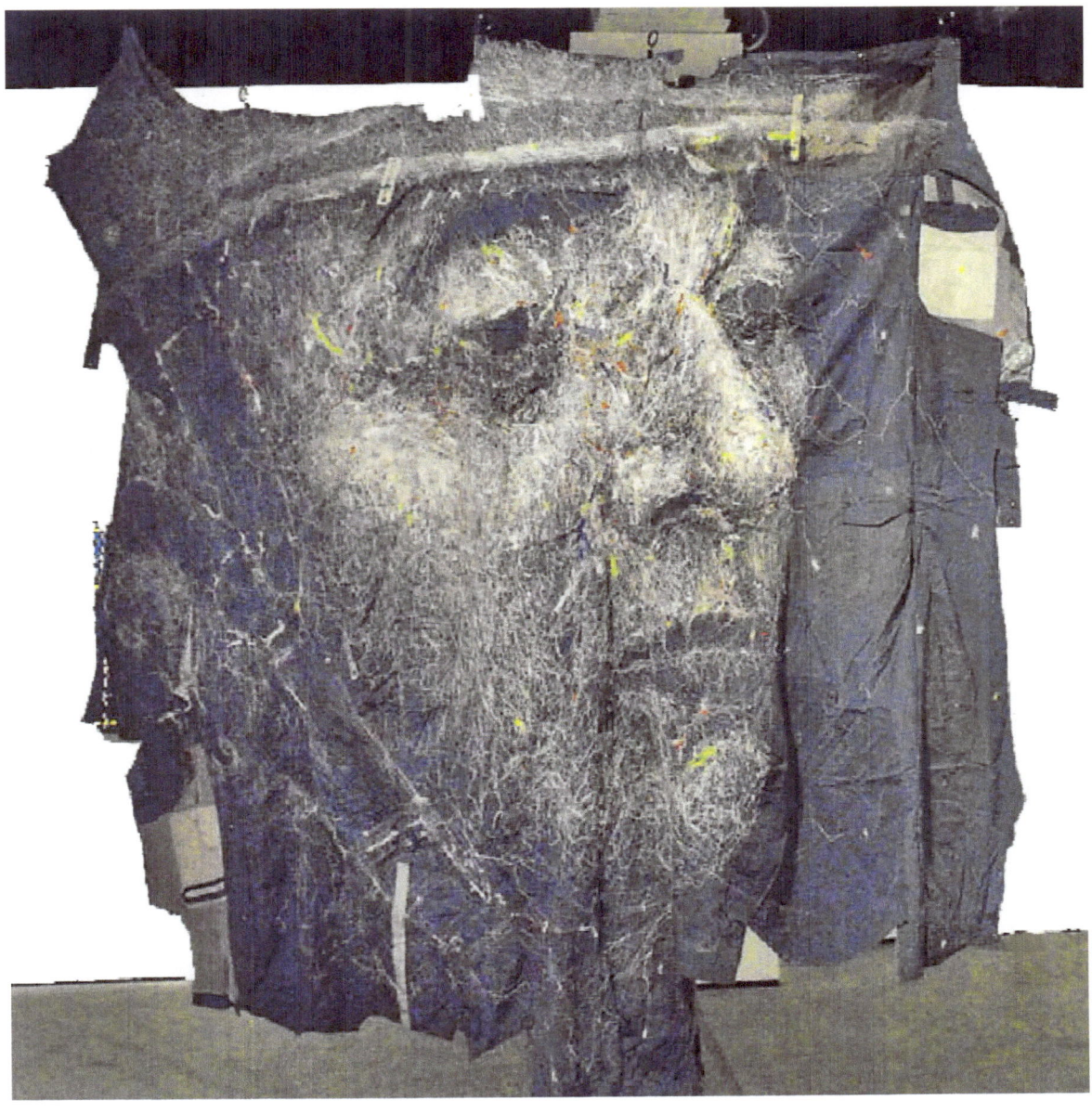

Nubigi, 000, 080　　102" x 76"　　Sewing on cloth

Katherine Knauer

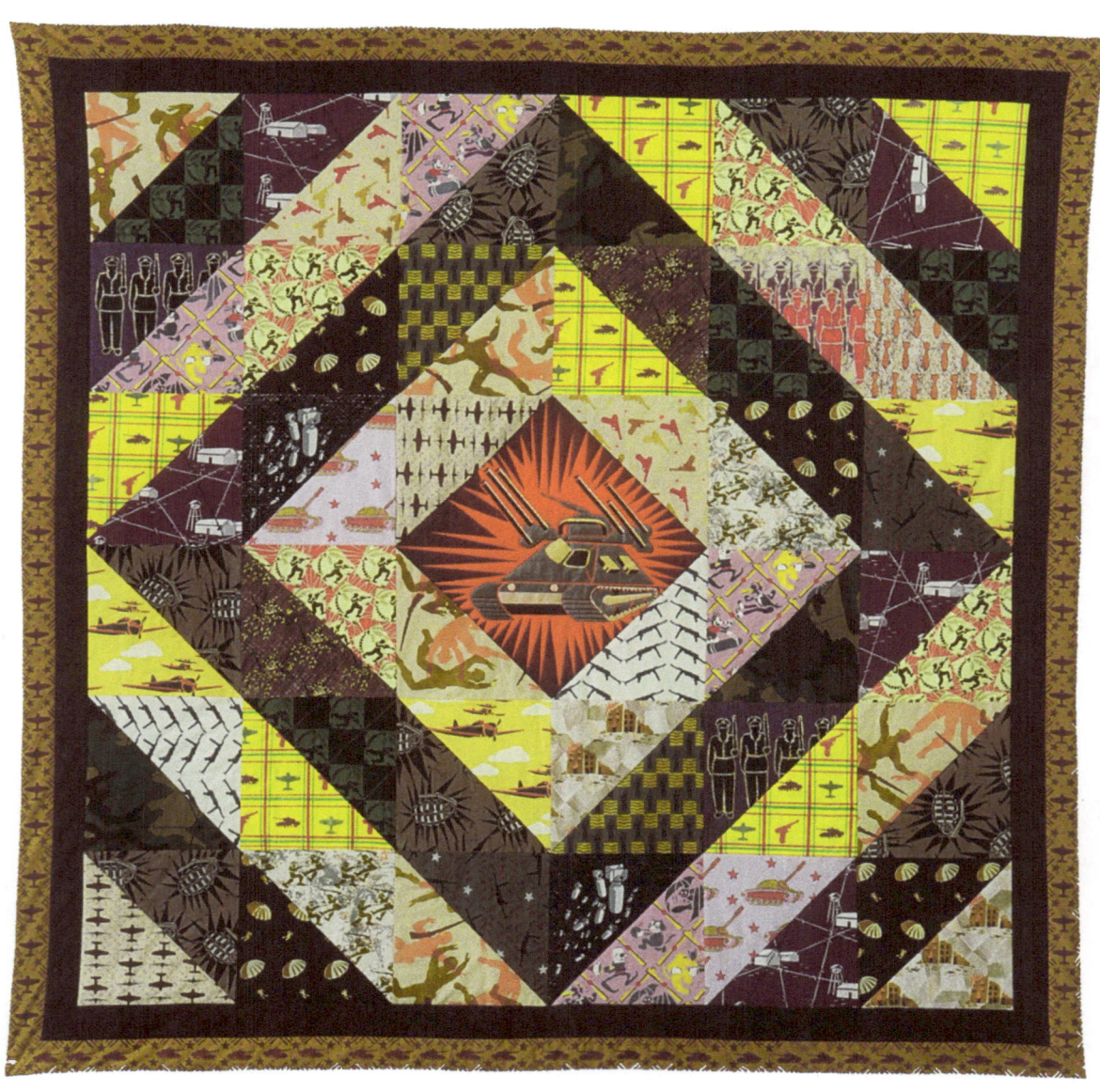

Conventional Forces. 84" x 84" x 0.5" Hand-printed cotton fabrics; machine quilted

Nancy Koenigsberg

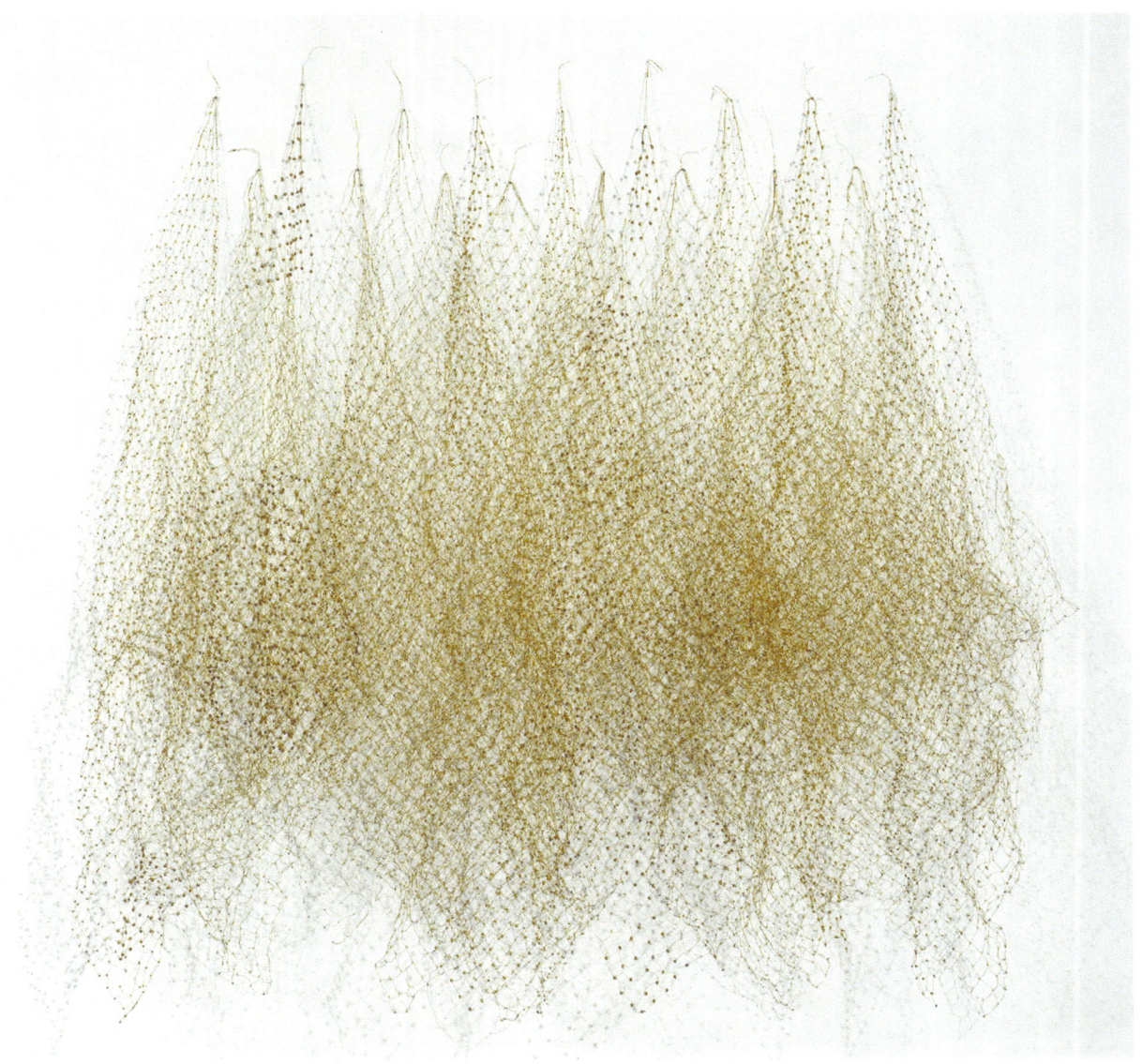

Morning Light . 78″ x 88″ x 15″ Coated copper wire and glass beads; knotted

Nancy Koenigsberg

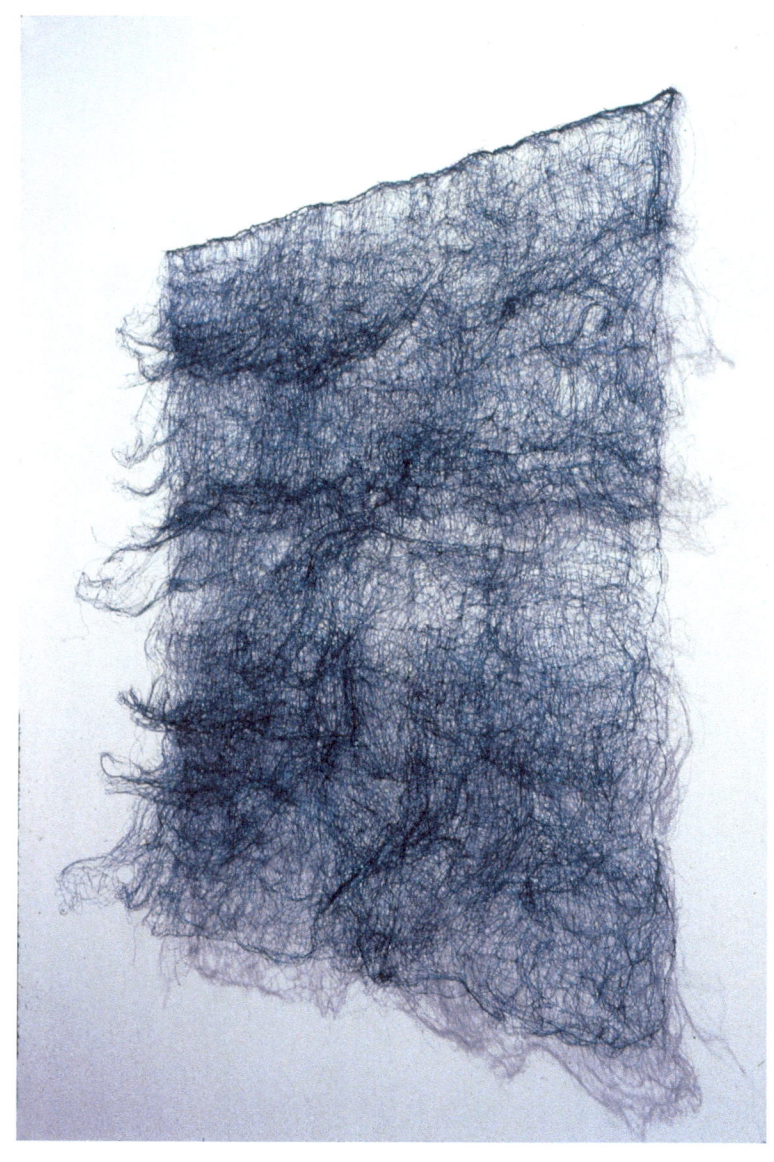

Sea/Sky 60″ x 60″ x 8″ Coated copper wire, woven

Daryl Lancaster

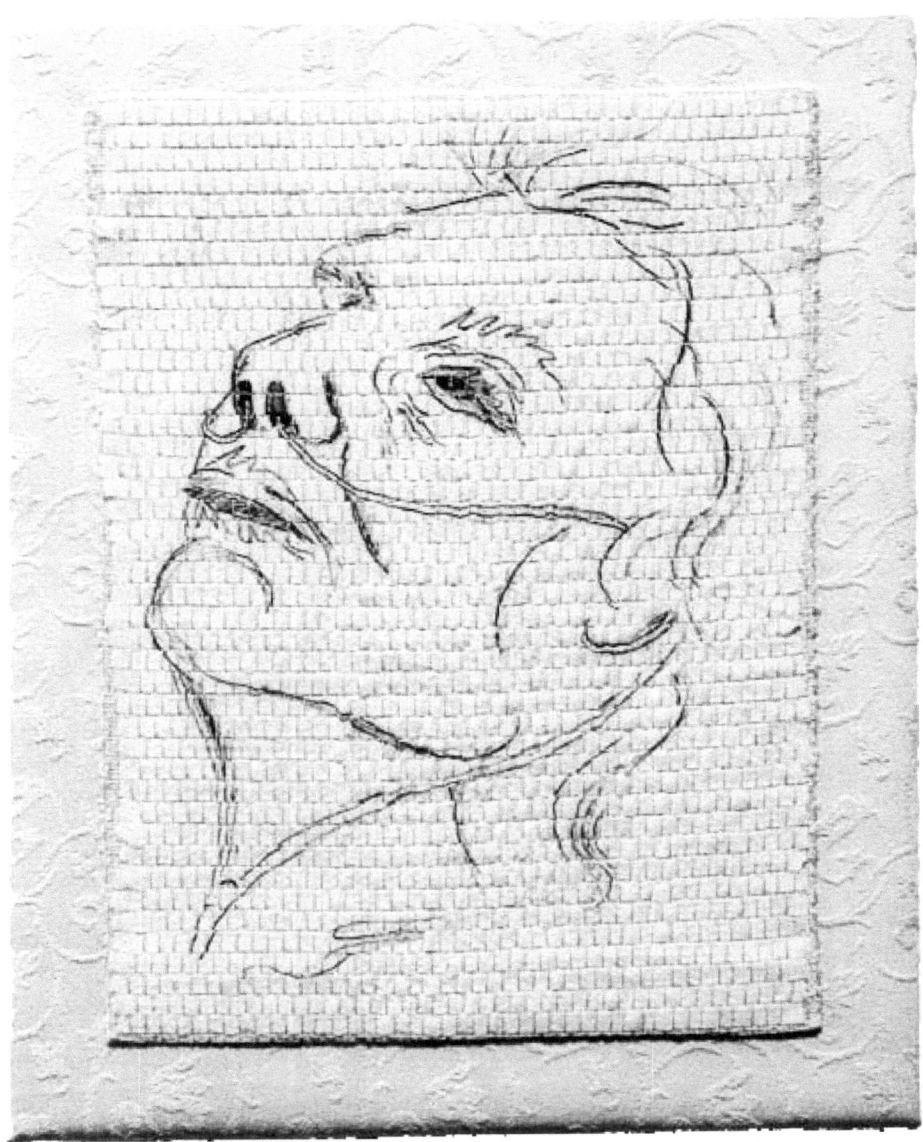

Watching Death Come 13" x 9" x 1" Digital print from original drawing on treated habotai silk cut into strips, rewoven in inlay technique with a cotton ground and rayon tie-down thread.

Janet Levine

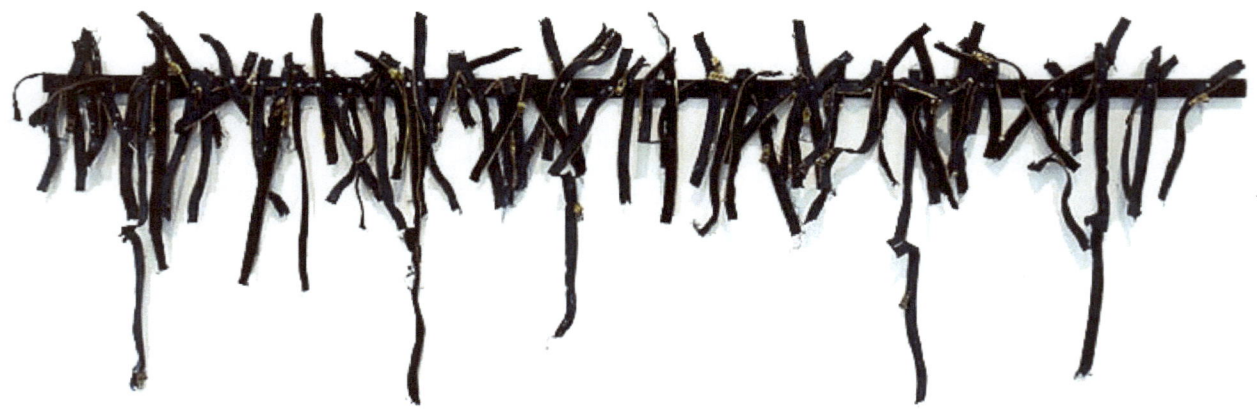

Untitled 27" x 50" Wood, nails and zippers.

Elaine Longtemps

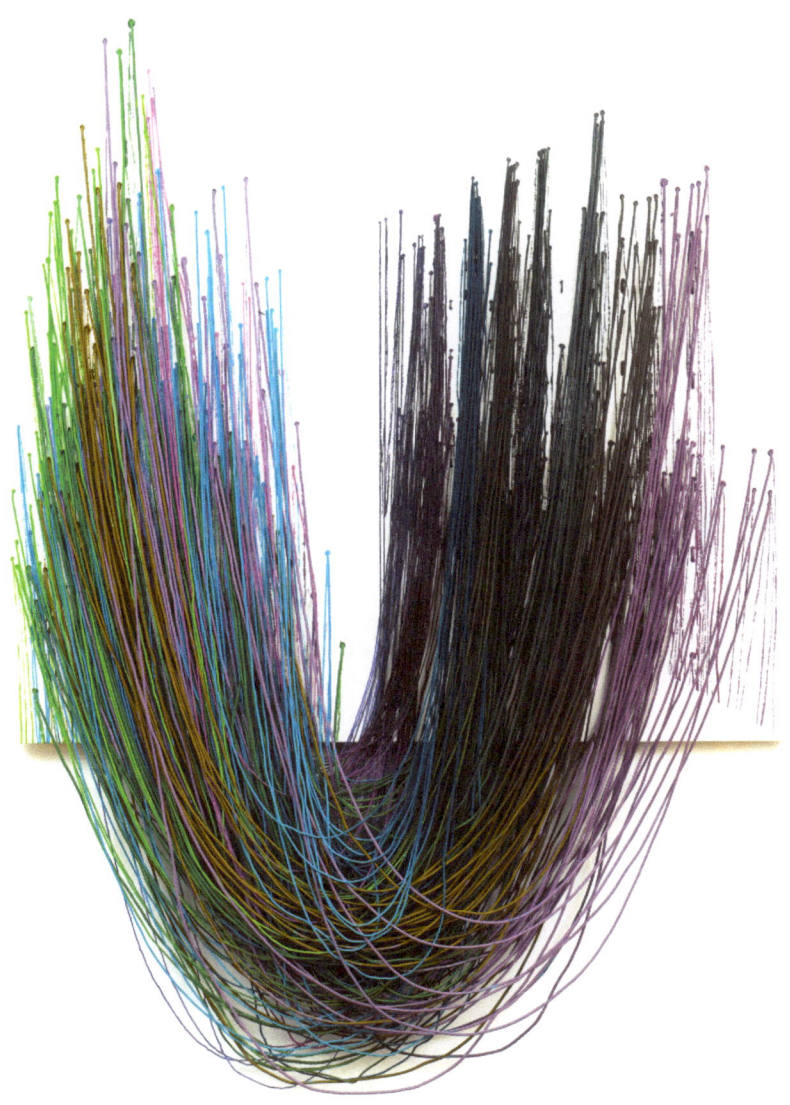

Extension/Velocity 106″ x 72″ x 3″ Hand-painted cotton ropes, gessoed cotton canvas, acrylic polymer, pencil grid; knotting, stitching, draping, painting.

Susan Martin Maffei

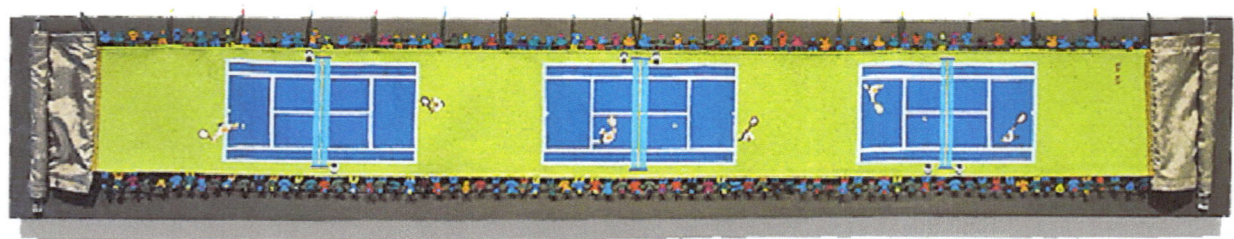

Sport Series - Tennis, the US Open. 14" x 65". Crochet and woven tapestry; wool, silk weft.

Susan Martin Maffei

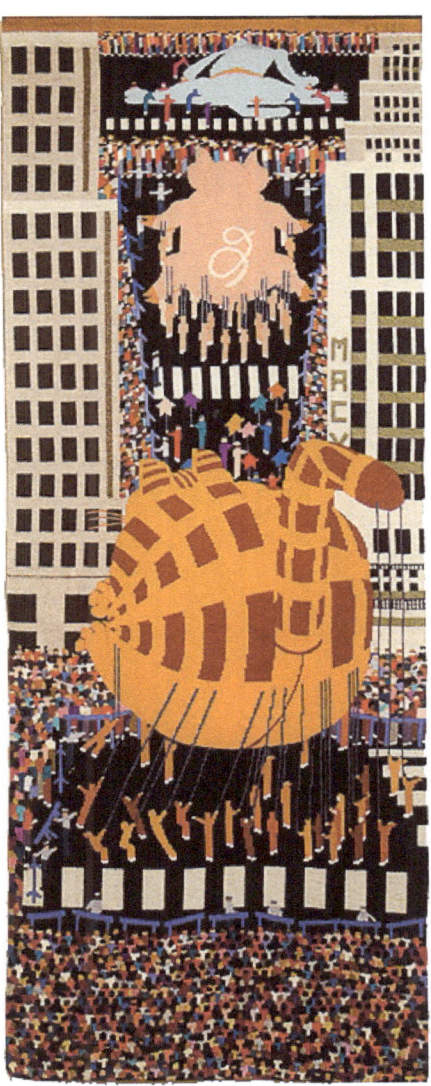

View up 7th Ave 80" x 30" Woven tapestry; wool, linen, silk weft.

Patricia Malarcher

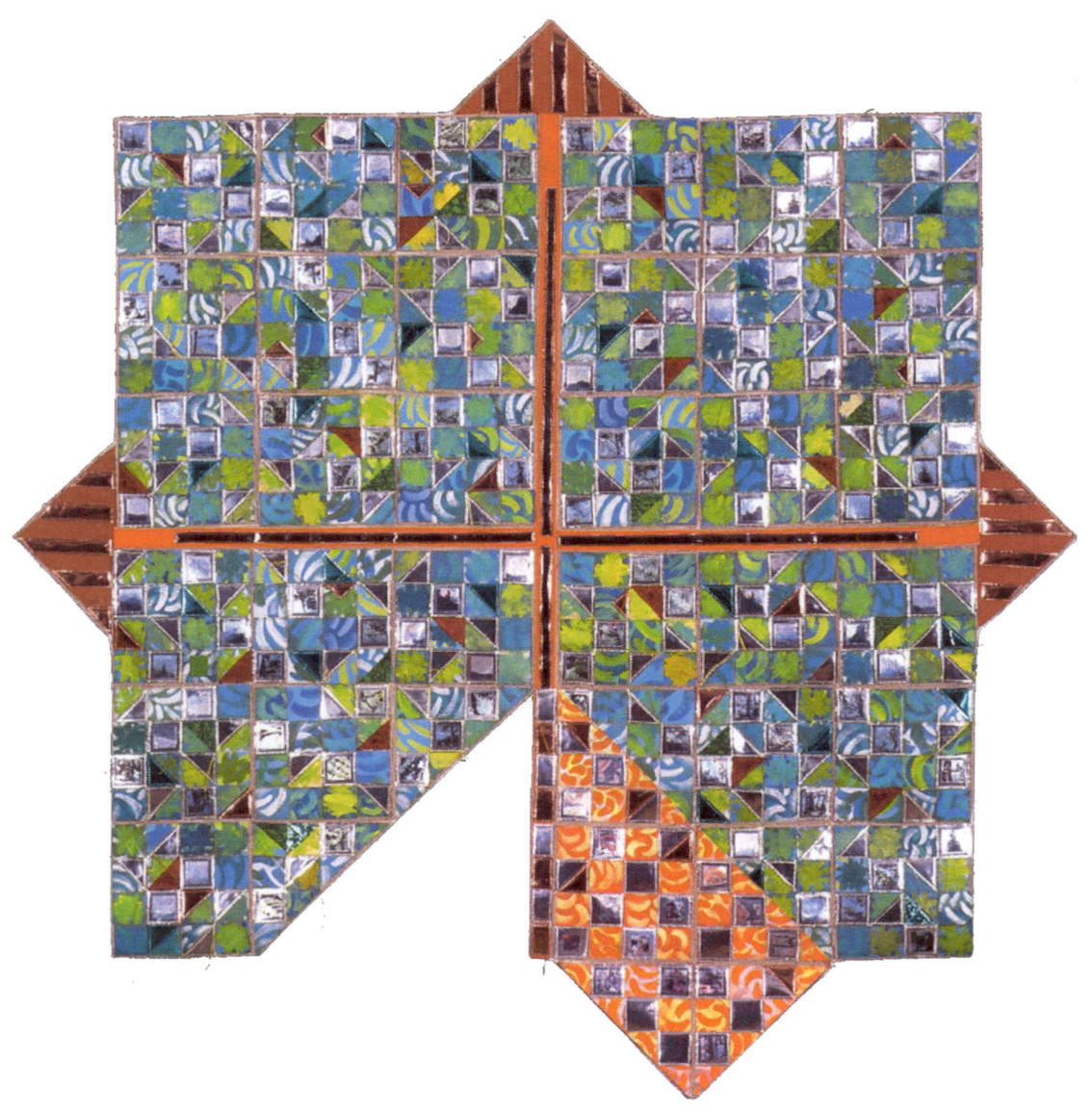

Terre Verte 47" x 43" Fabric, mylar, paint, photo transfer, machine sewn.

Saberah Malik

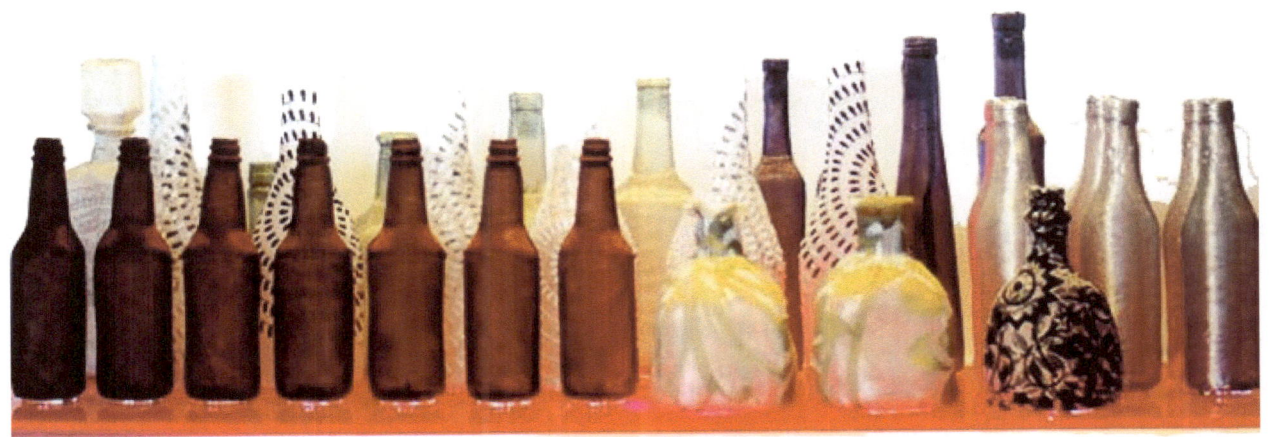

Teetotaller's Recollections. 16" x 16" x 48". Fabric, acrylic bases; shibori.

Barbara Maxey

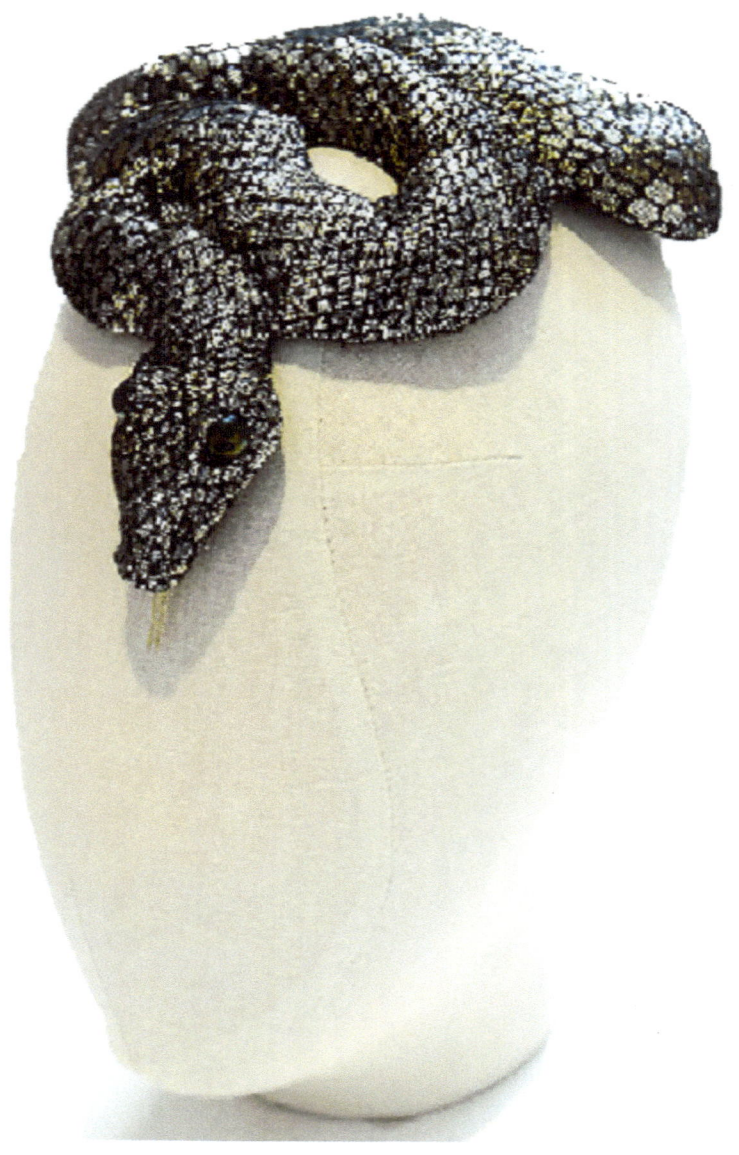

Slinky (Hat) 2" x 6" x 9" Metallic fabric, buckram, wire, antique buttons; millinery construction.

Dorothy McGuinness

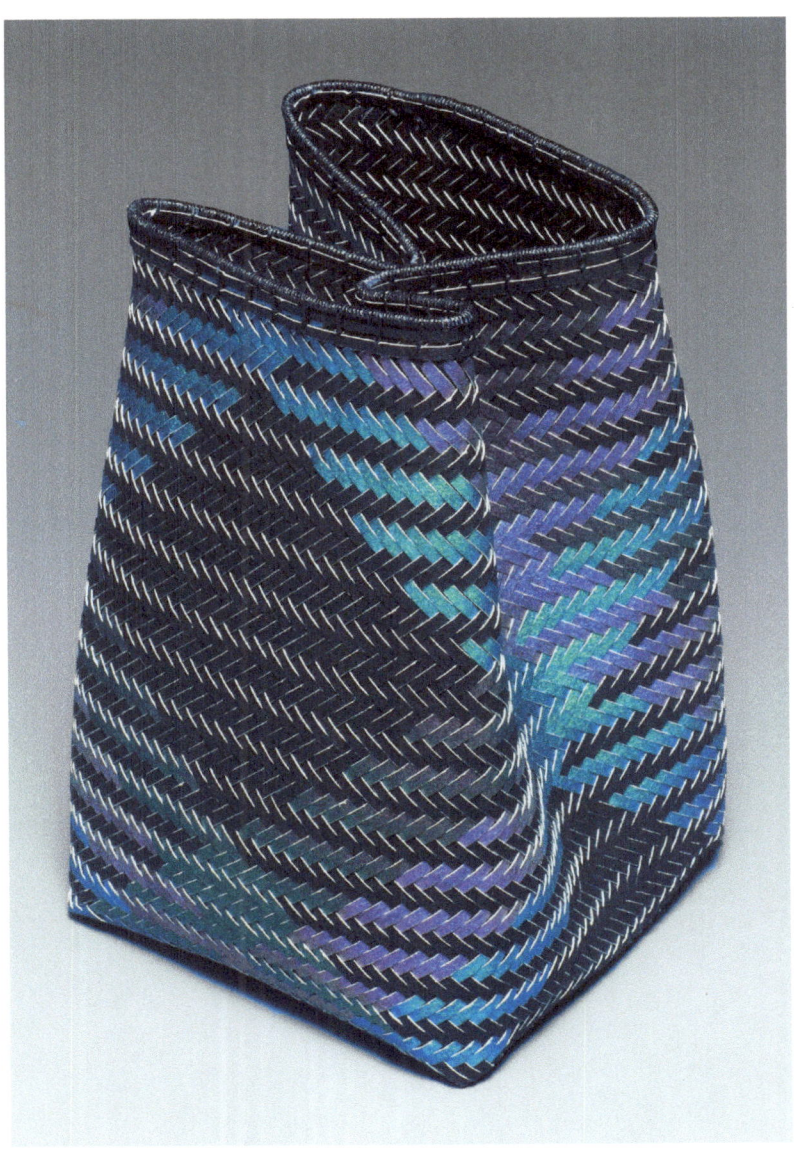

Pleats and Plaids 8" x 5" x 5" Watercolor paper, acrylic paint; basketry

Dorothy McGuinness

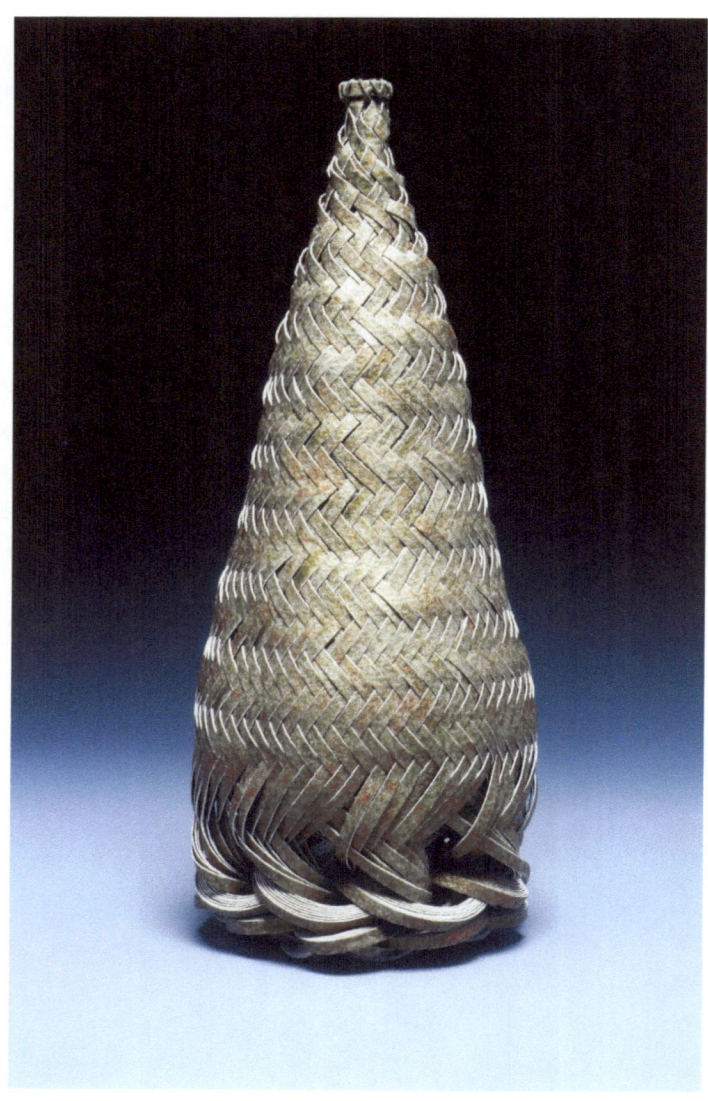

Topiary Twist 10" x 4" x 4" Watercolor paper, acrylic paint; basketry.

Rebecca Mushtare

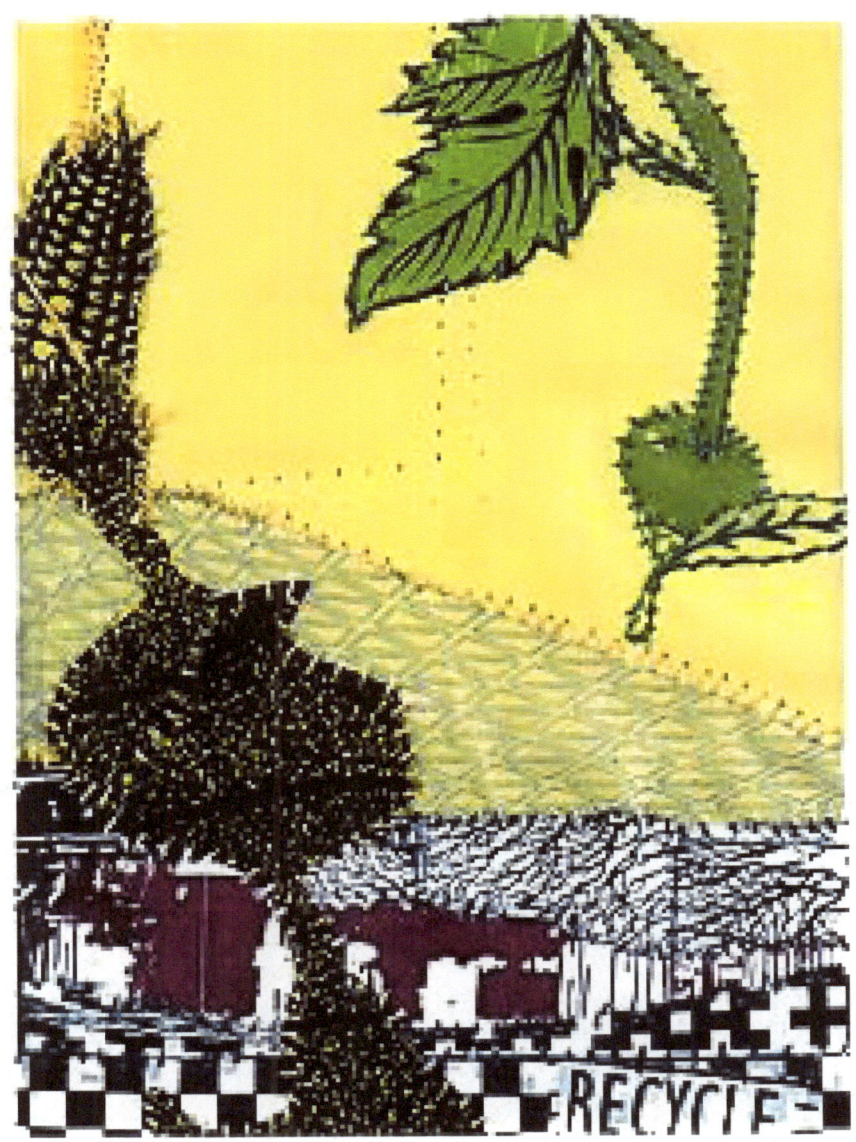

Consumption Portrait #5. 7" x 5.25" Recycled plastic shopping bags and thread.

Bonnie Peterson

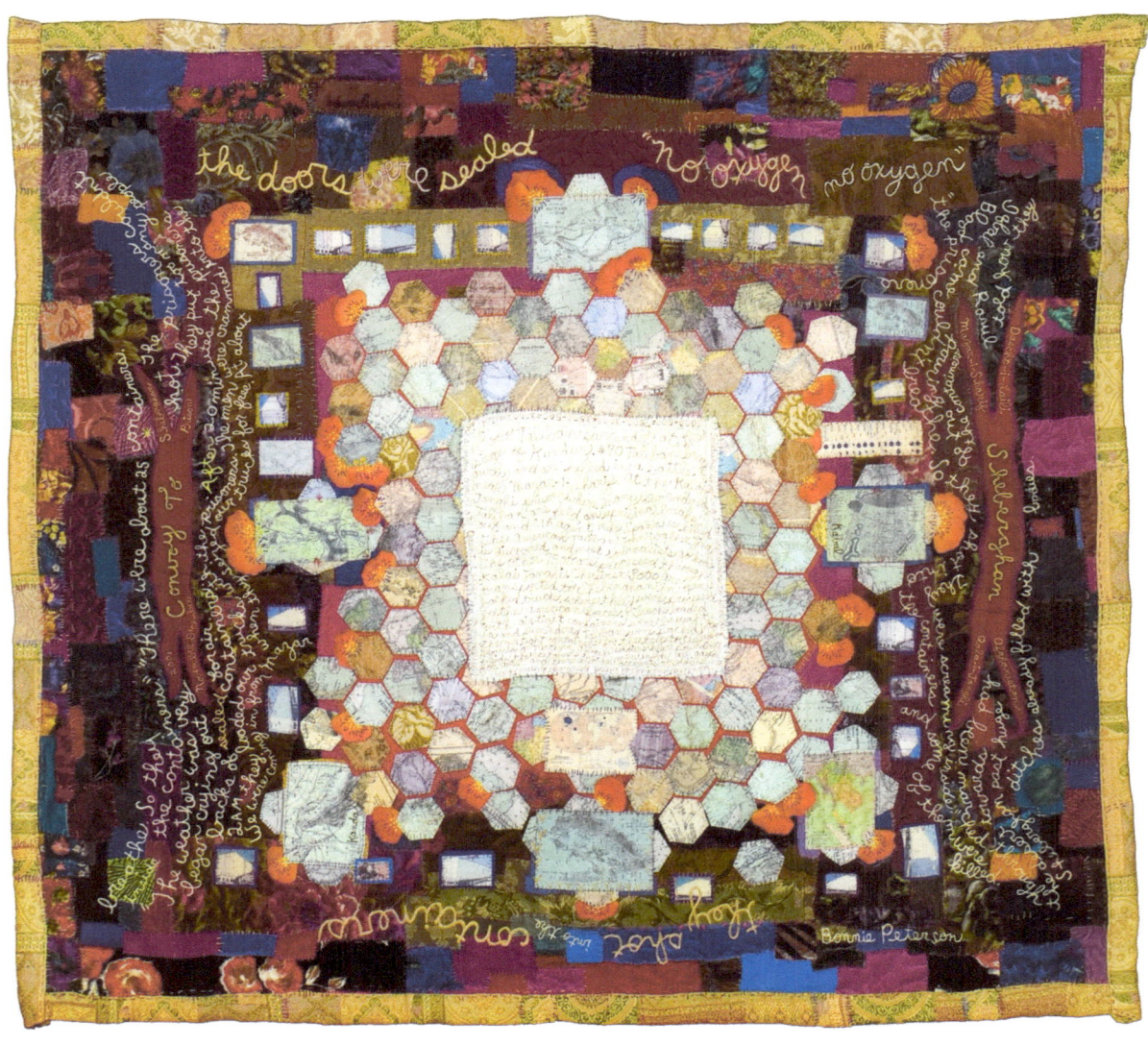

Convoy to Sheberghan 50″ x 56″ Heat transfers, embroidery, satin, silk, velvet, brocade; hand and machine stitching

Wen Redmond

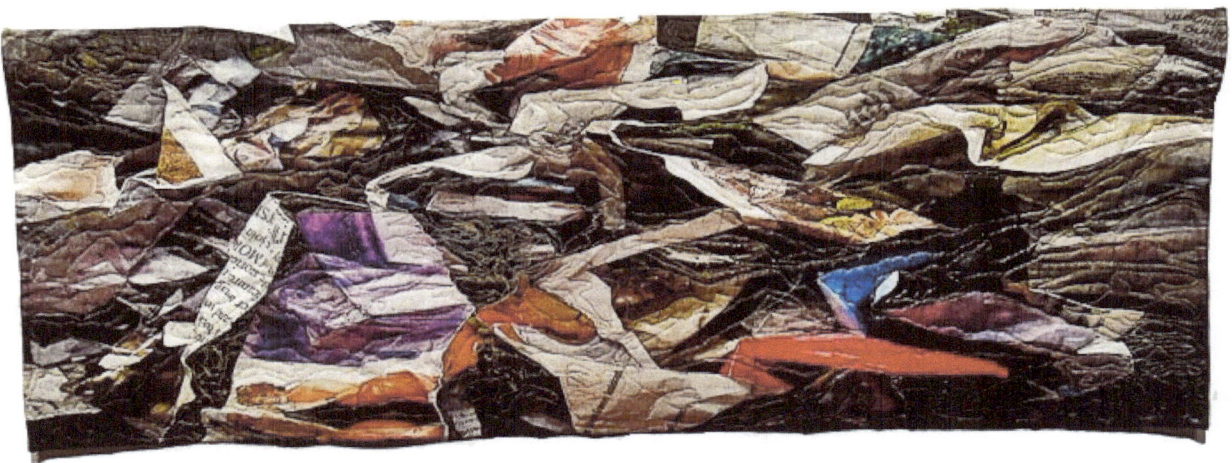

Crumpled. 15" x 44" x .25" Digital fiber, Belgian linen; stitched and layered

Linda Rettich

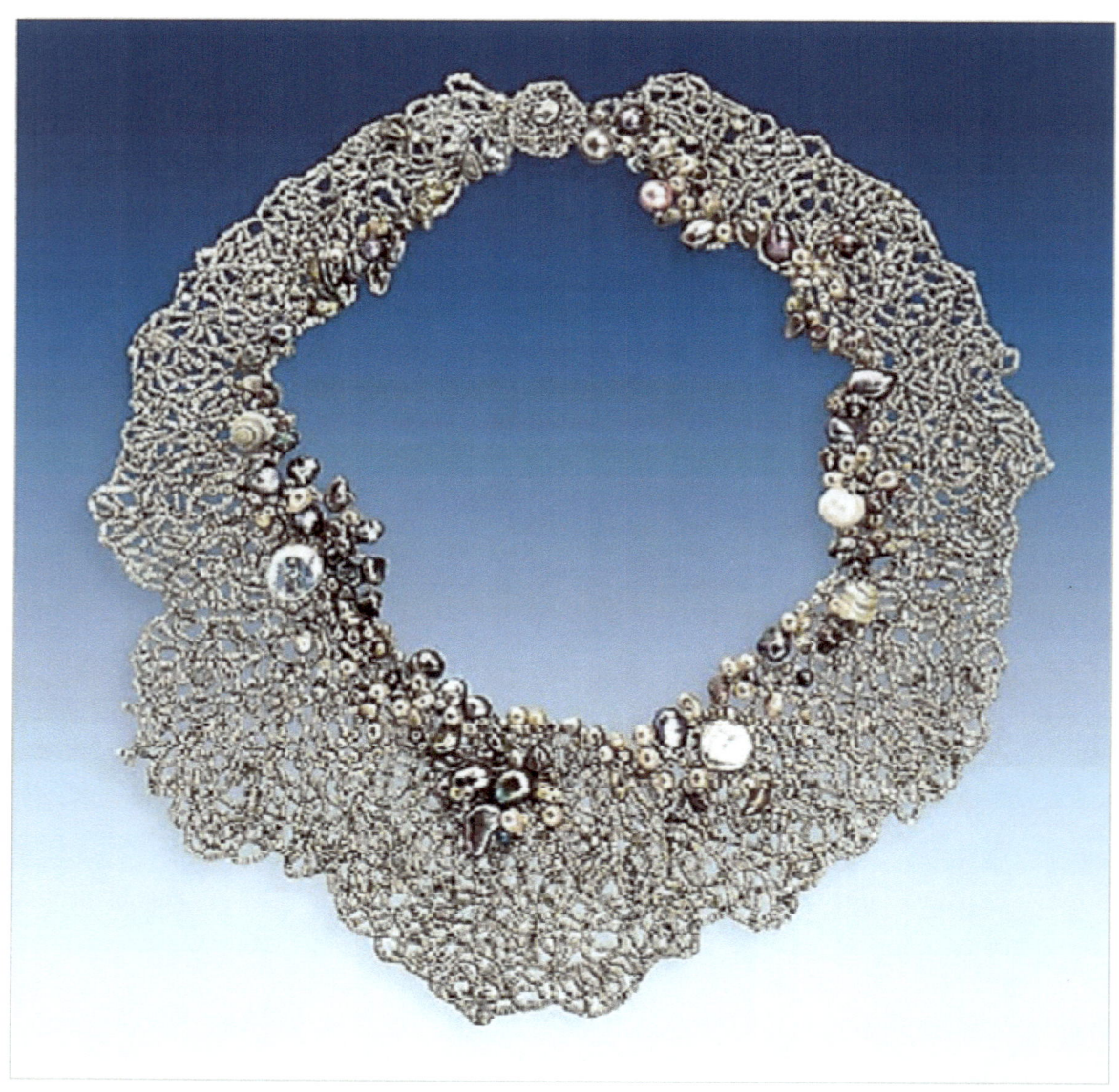

Sea Fan Collar 8.5" x 8.5" Vintage seed beads, pearls.

Michael F. Rohde

Tibetan Prayers 49.5" x 38.5" x 0.5" Navajo wool, Tibetan wool, madder; tapestry.

Donna Rosenthal

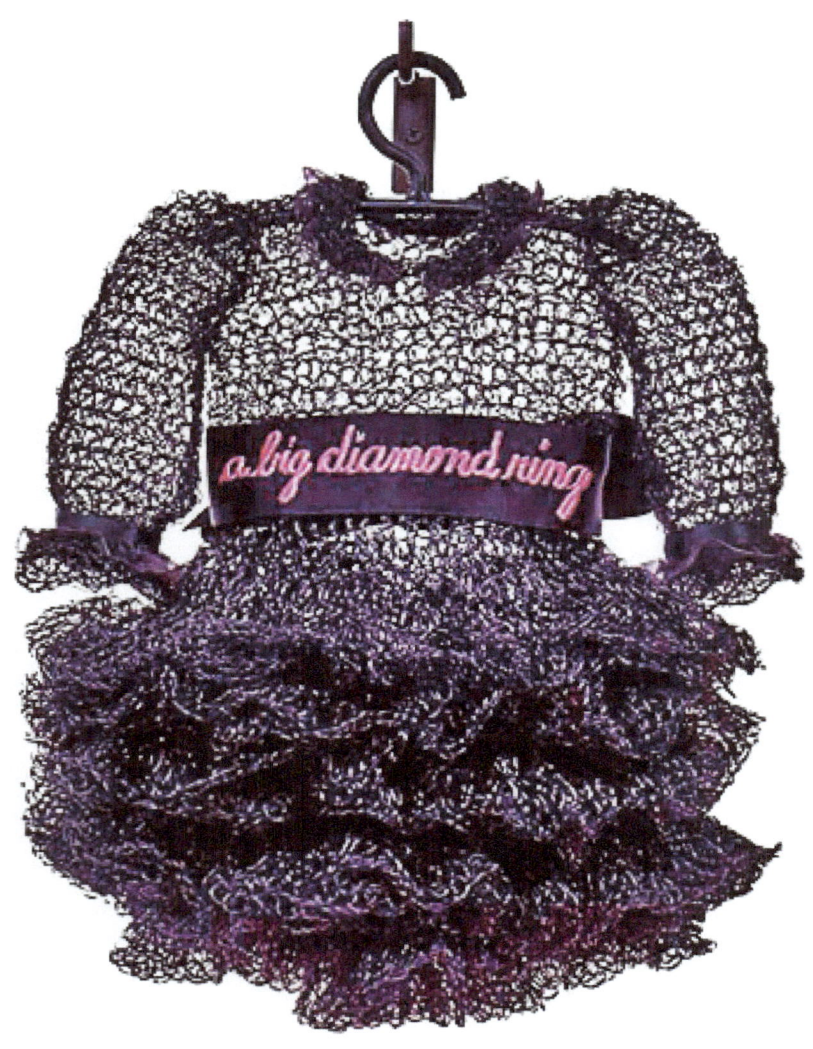

Little Girl's Wish List 13.5" x 11" x 11" Crocheted metal wire, ribbon with embroidered text.

Lois Russell

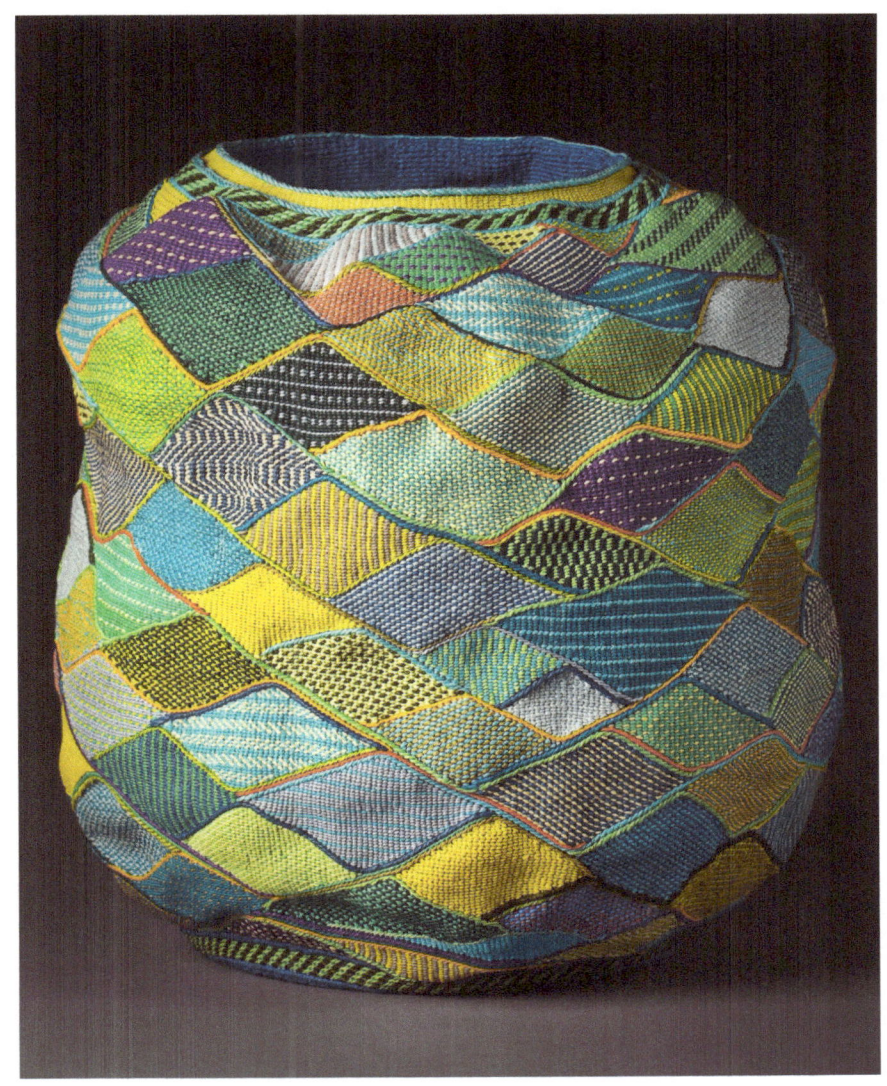

Blub Blub 13" x 13" x 13" Twined waxed linen thread.

Joy Saville

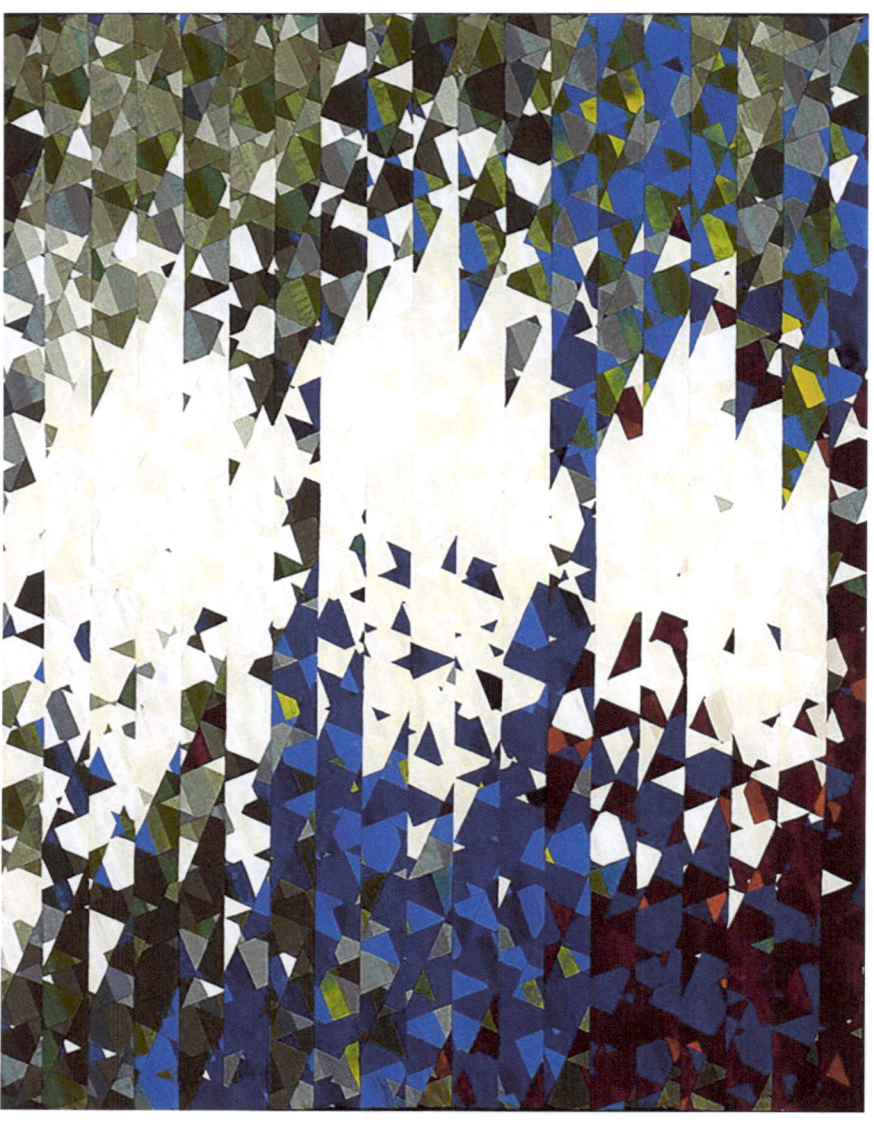

Sacred Space 58" x 45" x 1" Cotton, linen, silk; pieced, stitched, constructed.

Linda Friedman Schmidt

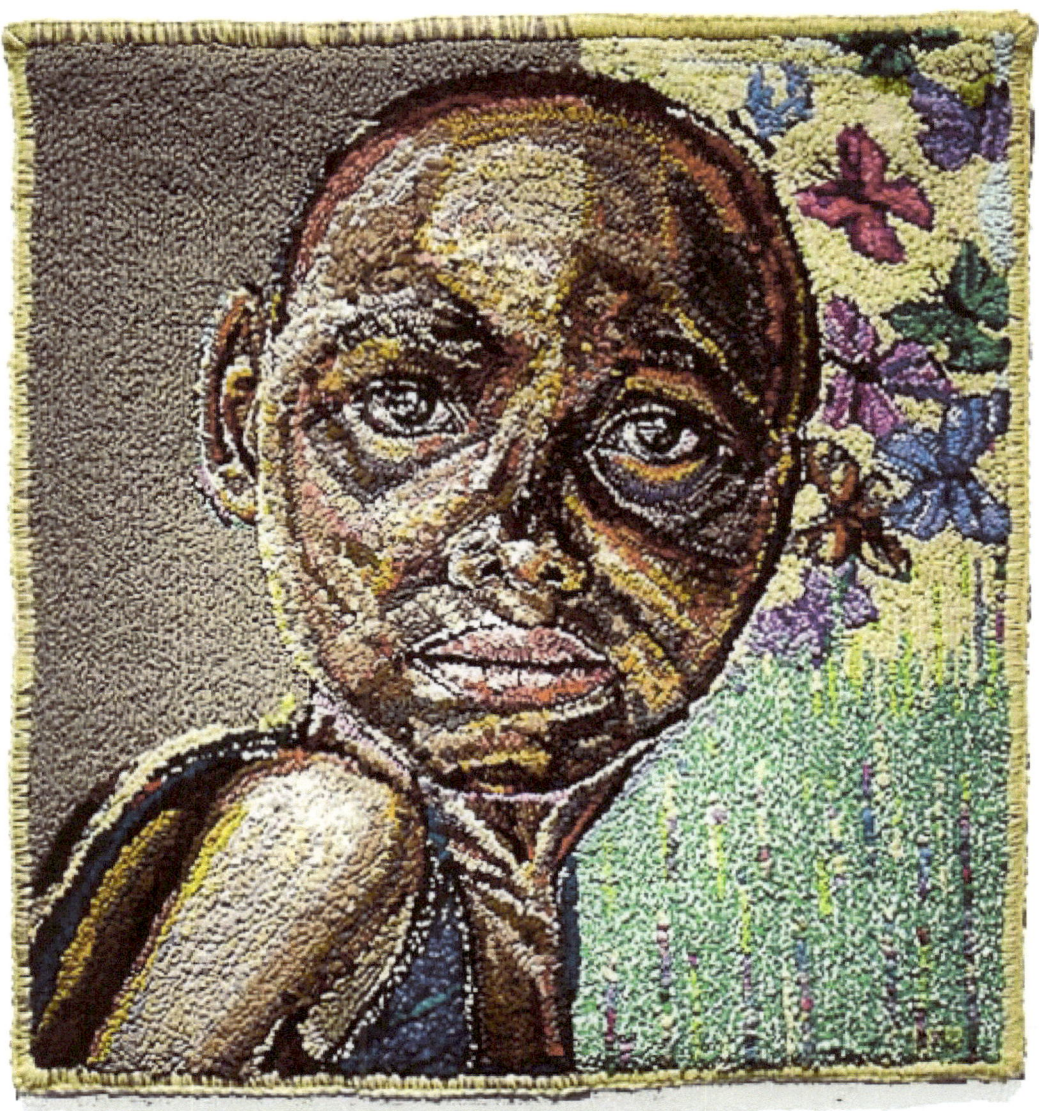

Refugee Never Free 26" x 24" x 1" Discarded clothing, hooked.

Larry Schulte

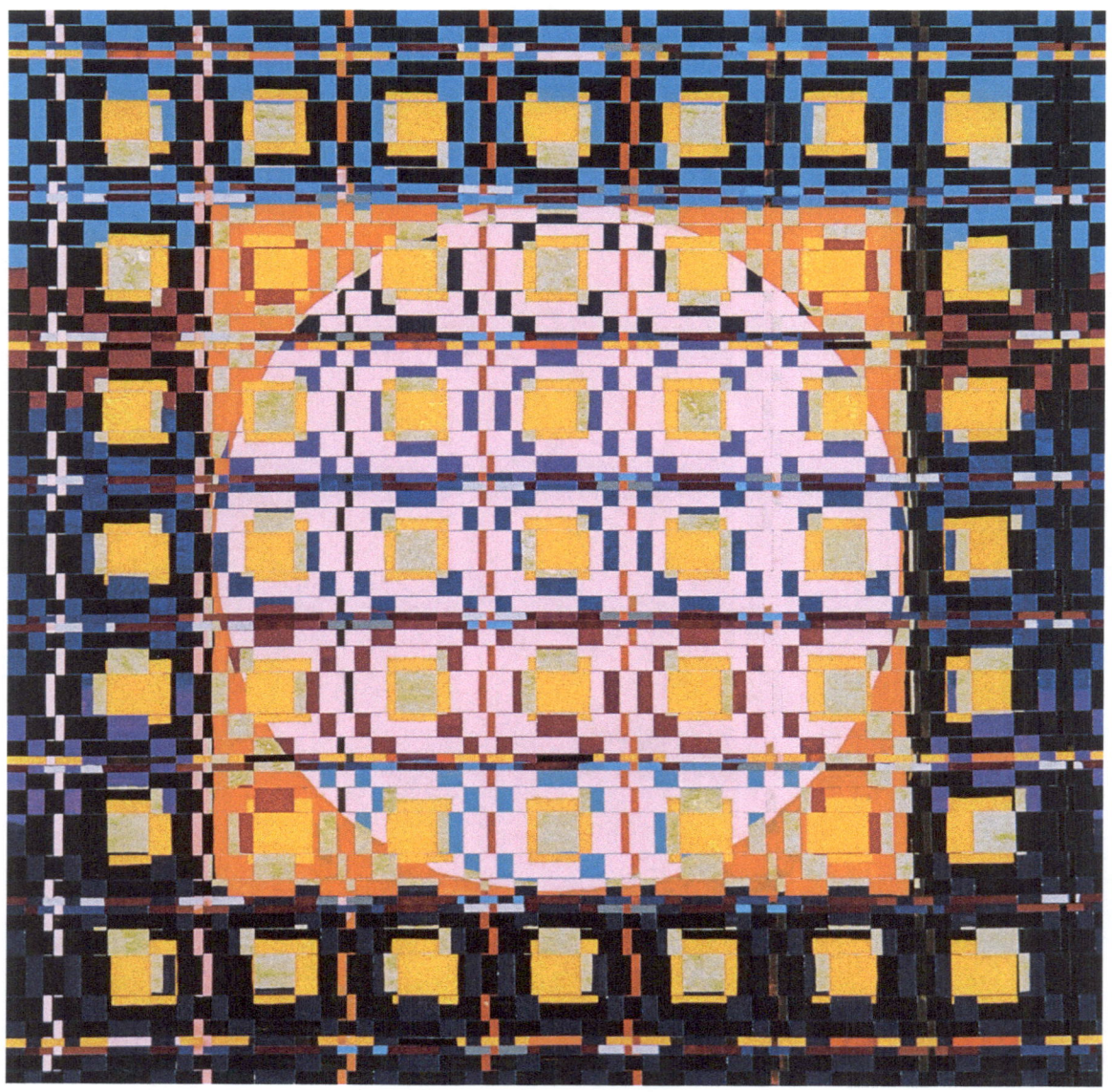

Flag 5 34" x 34" x 2" Acrylic paint on paper, cut in strips and woven.

Biba Schutz

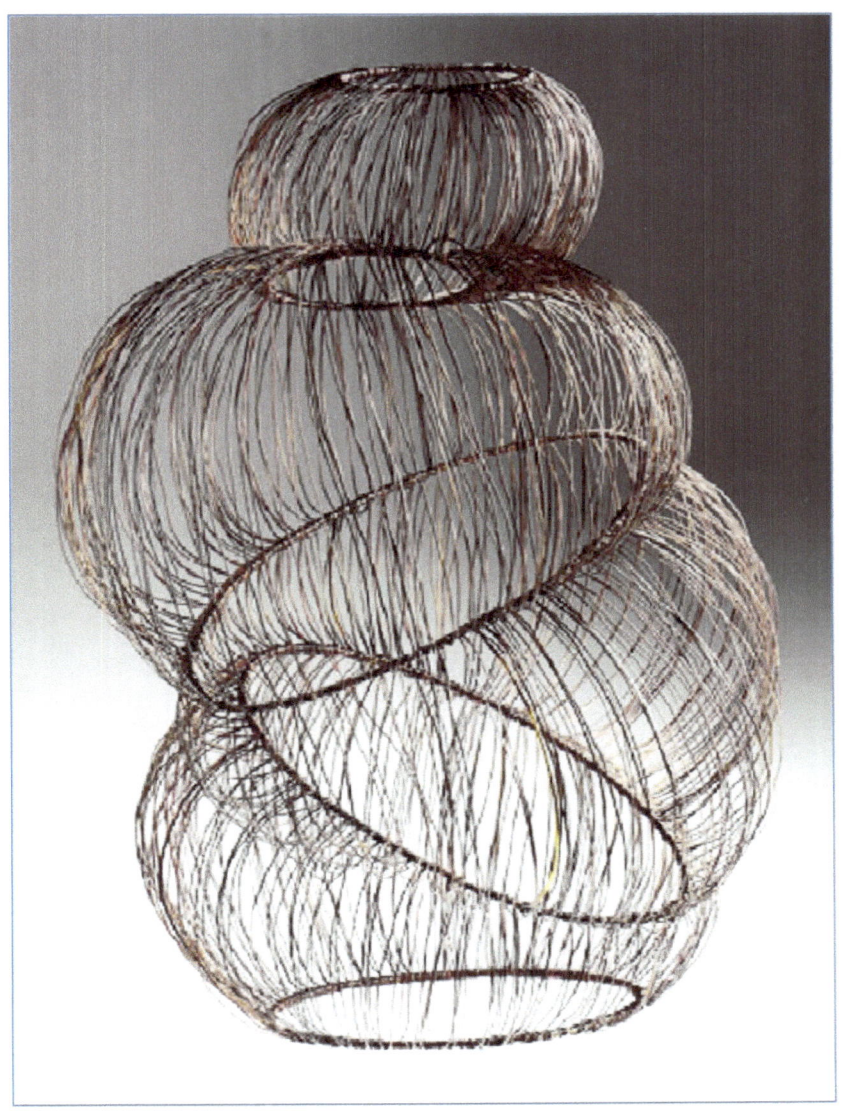

Fou Rolls Basket 17″ x 11″ x 12″ Copper and bronze; constructed, forged, wrapped.

Robin Schwalb

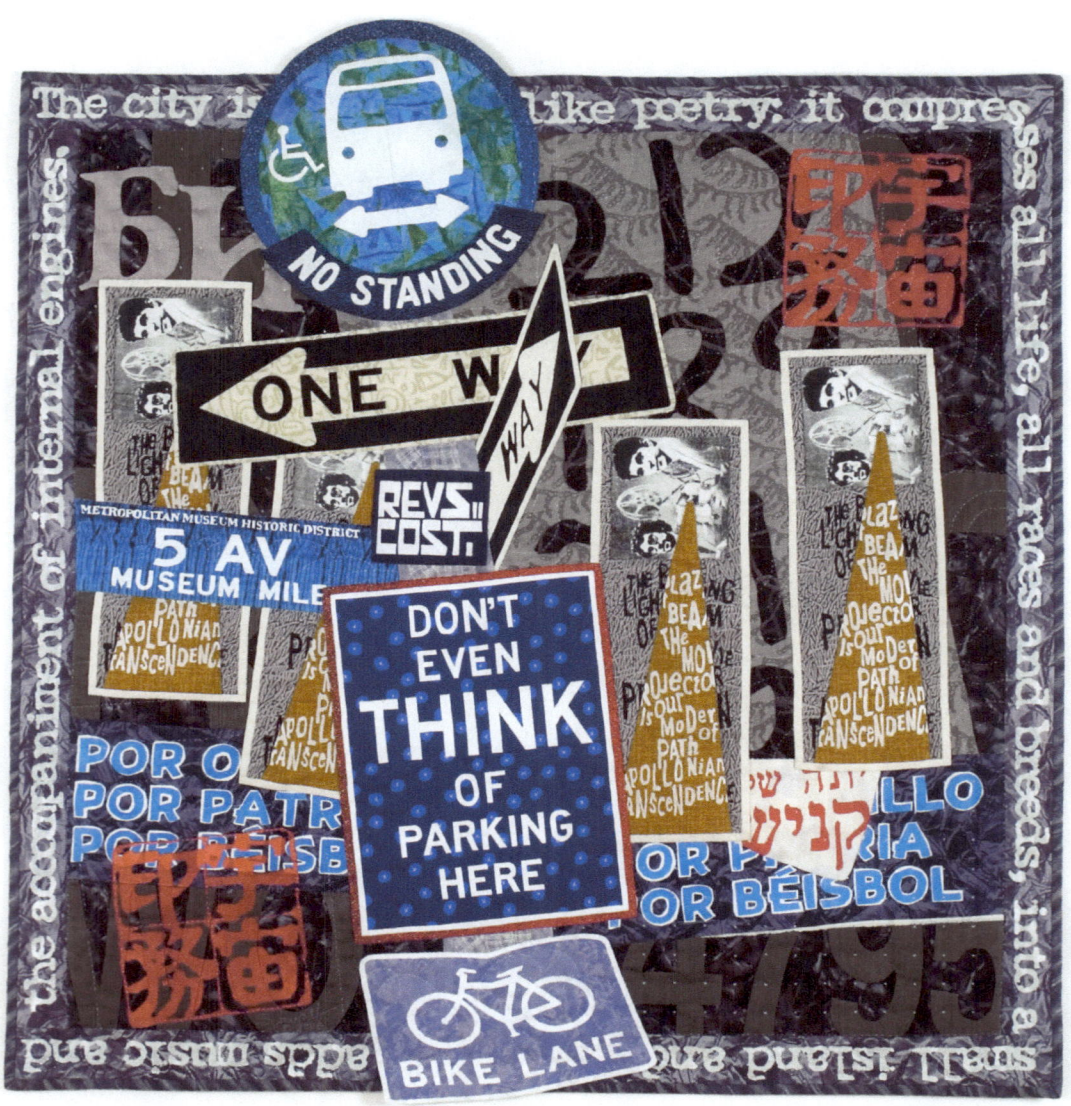

Noo Yawk, Noo Yawk 38" x 36" x. 0.25" Fabric; stenciled, silk-screened, pieced, appliquéd, quilted.

Won Ju Seo

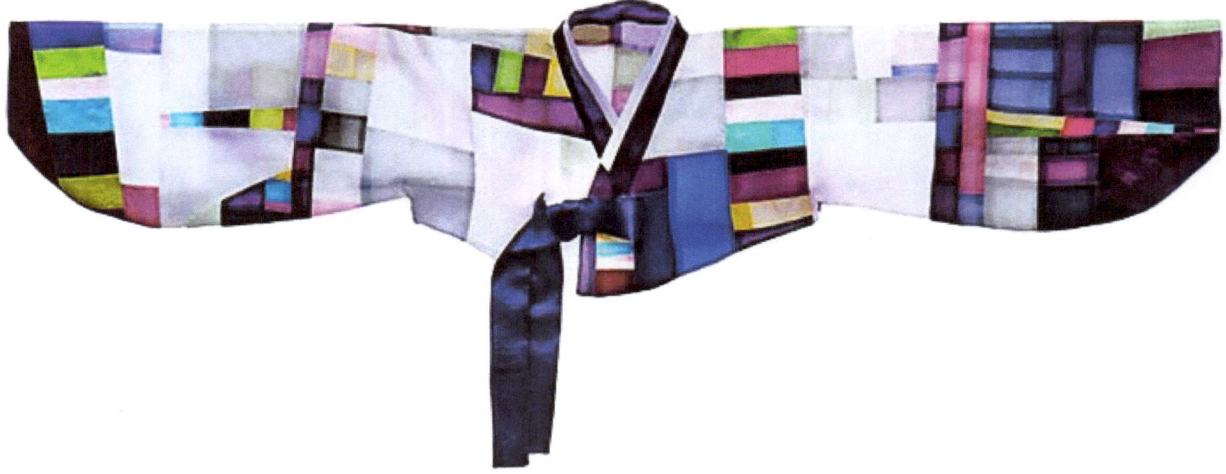

A Korean Woman in Modern Times #1 14" x 54.25" x 2". Silk, thread; hand sewing.

Adrienne Sloane

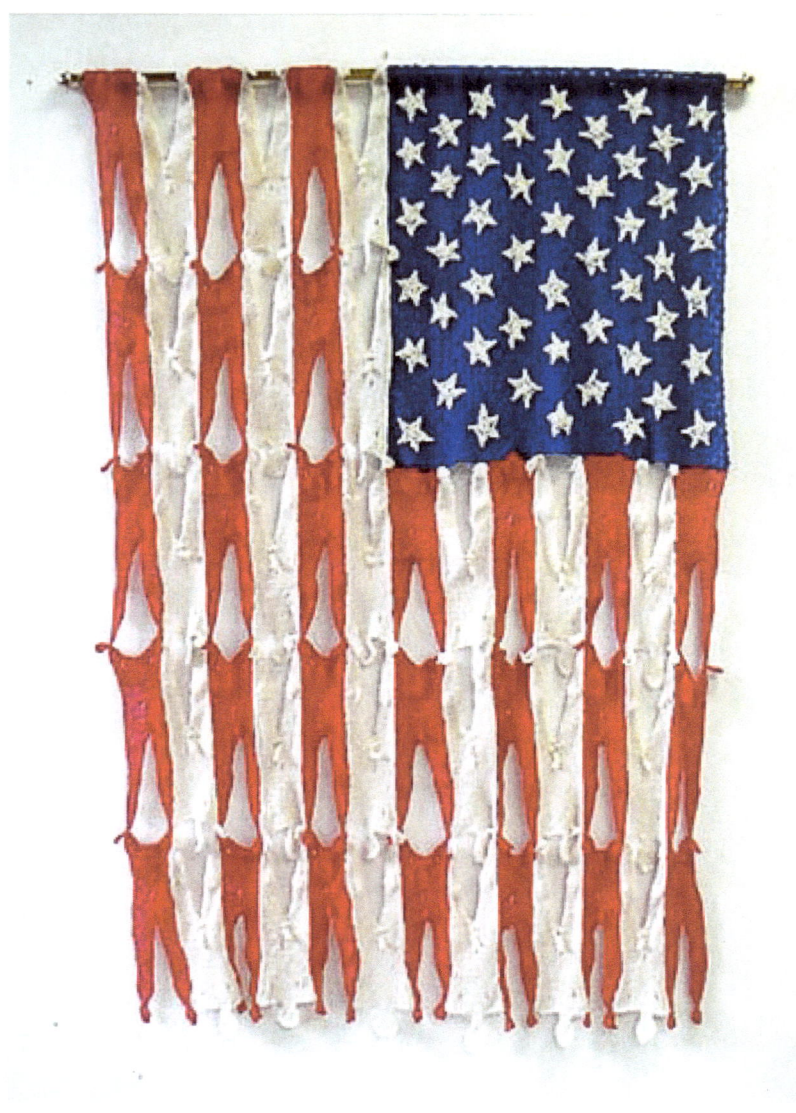

Fated Glory 55" x 46" Knit linen.

Christine Spangler

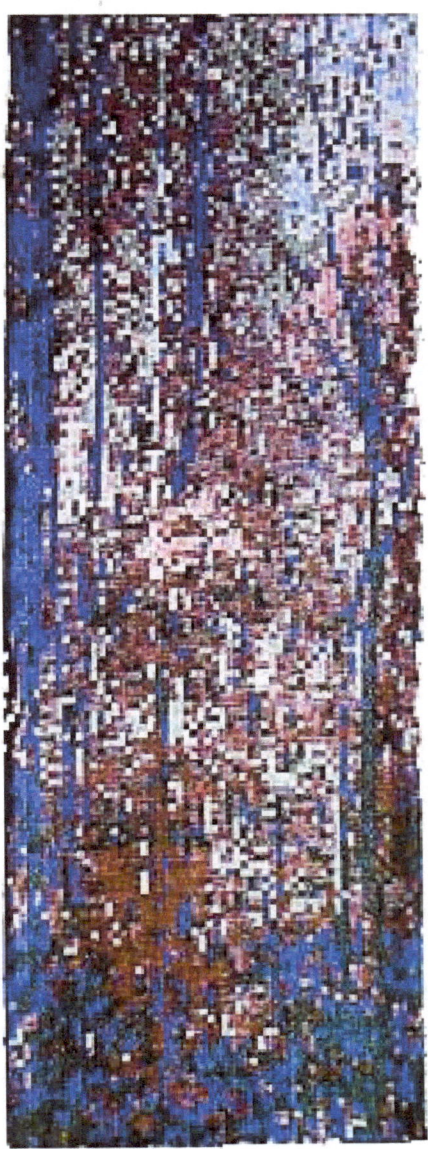

Pixilated Forest 84" x 28" x 1" Jacquard woven doubleweave, cotton and rayon.

Marcy Sperry

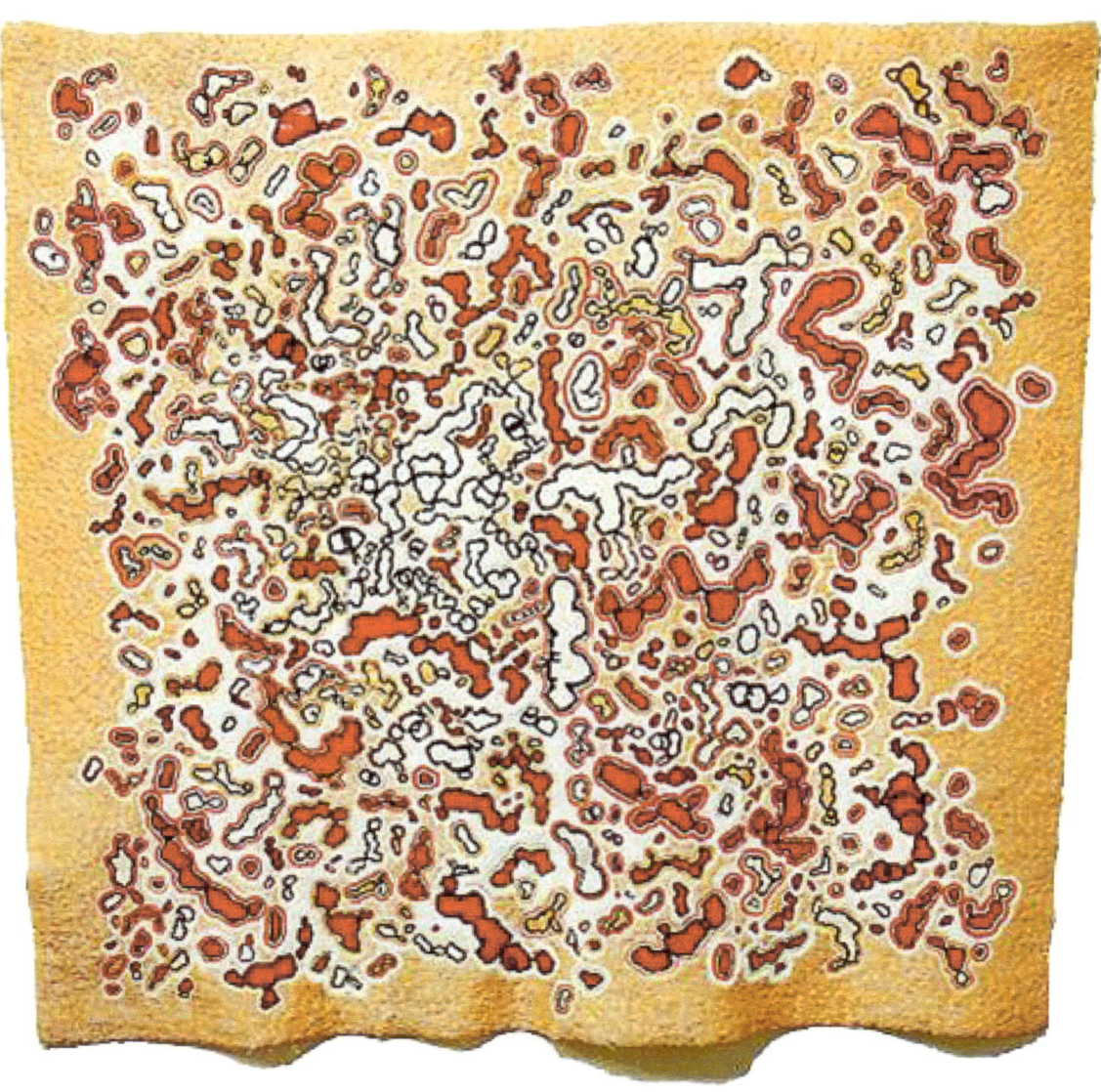

Micromanaged 45" x 45". Silk, seed beads; hand embroidery.

Ruth Tabancay

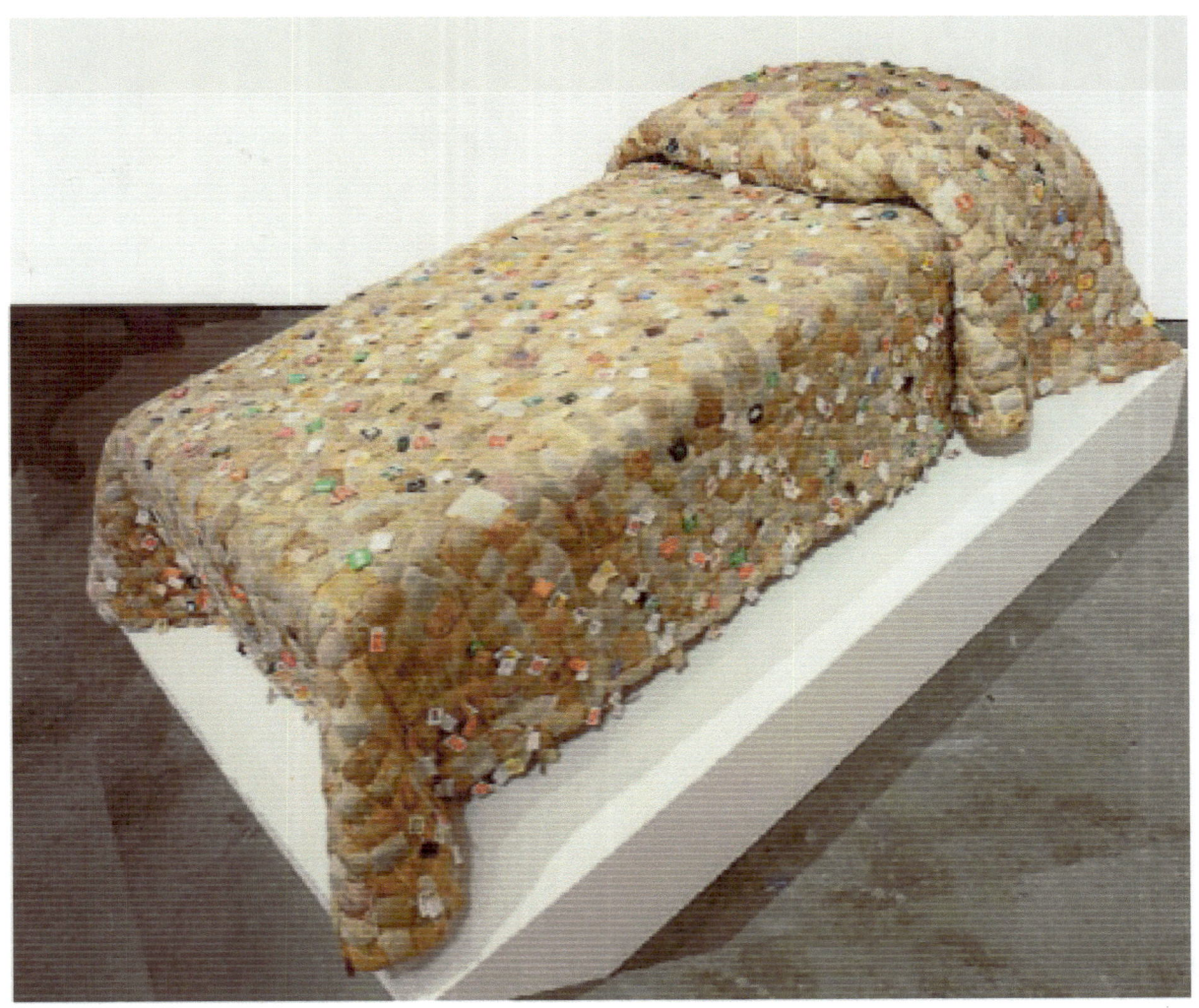

Extending the Useful Life. 26" x 33" x 65". Hand stitched tea bags.

Myrna Tatar

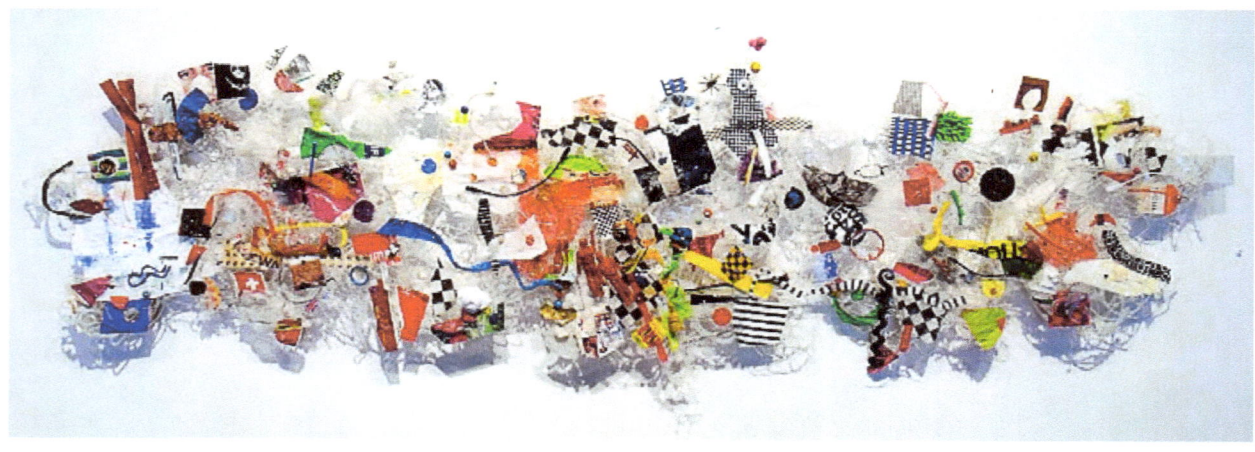

No U-Turn. 32" x 108" x 1". Polyamide, fabrics, paper, found materials.

Betty Vera

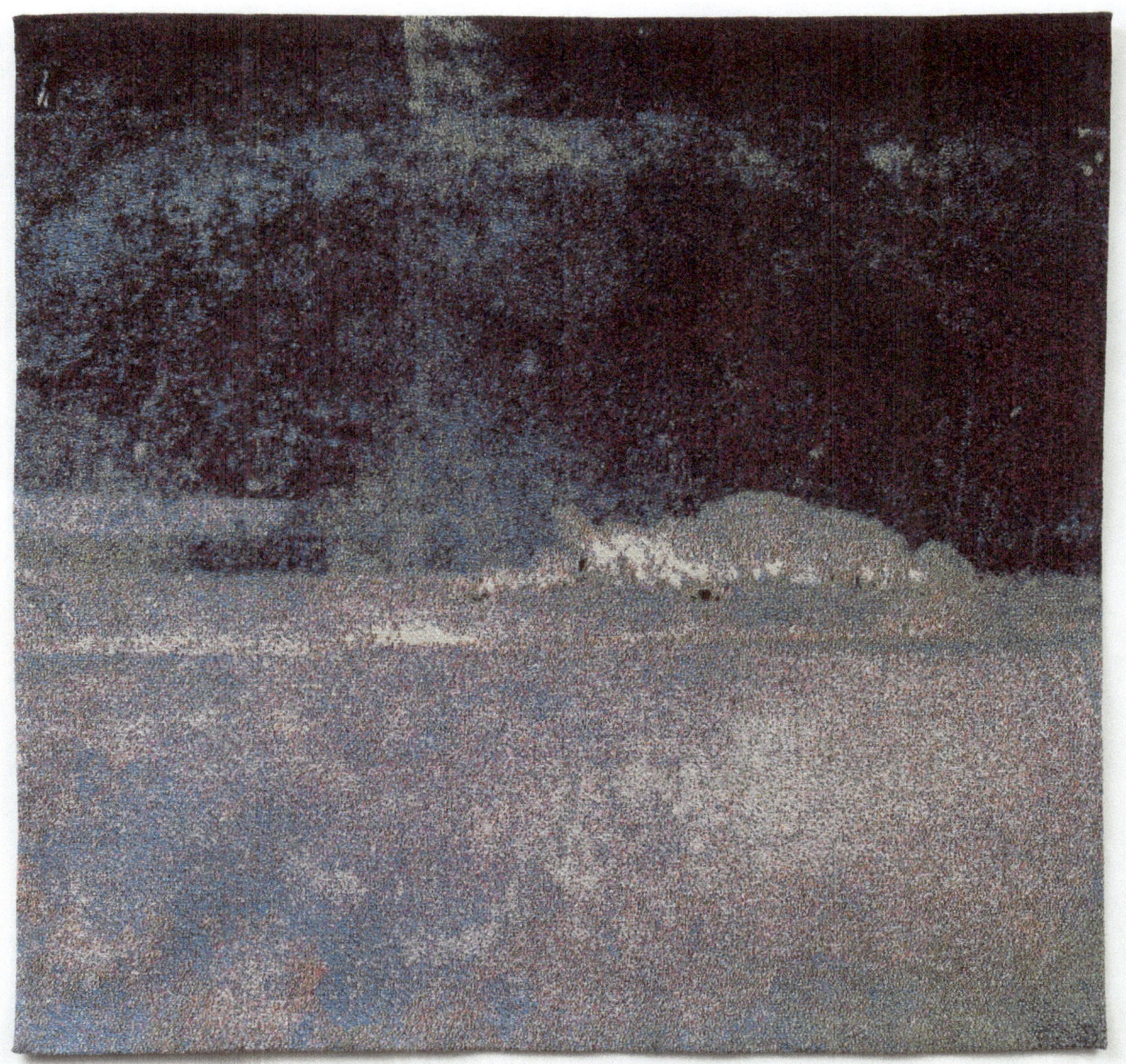

Division 44" x 46" x 1" Cotton; Jacquard tapestry

Grace Bakst Wapner

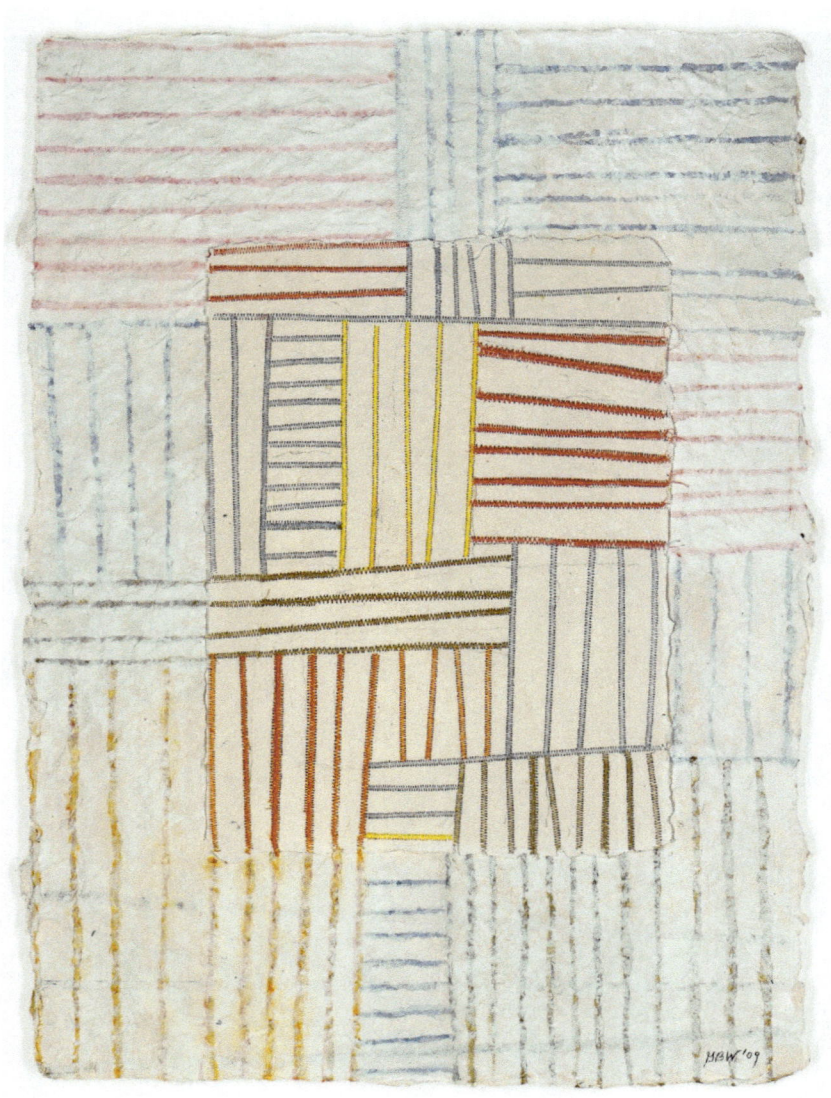

Leaving Home 27" x 22" x 1.5". Thread, paint, paper.

Kathy Weaver

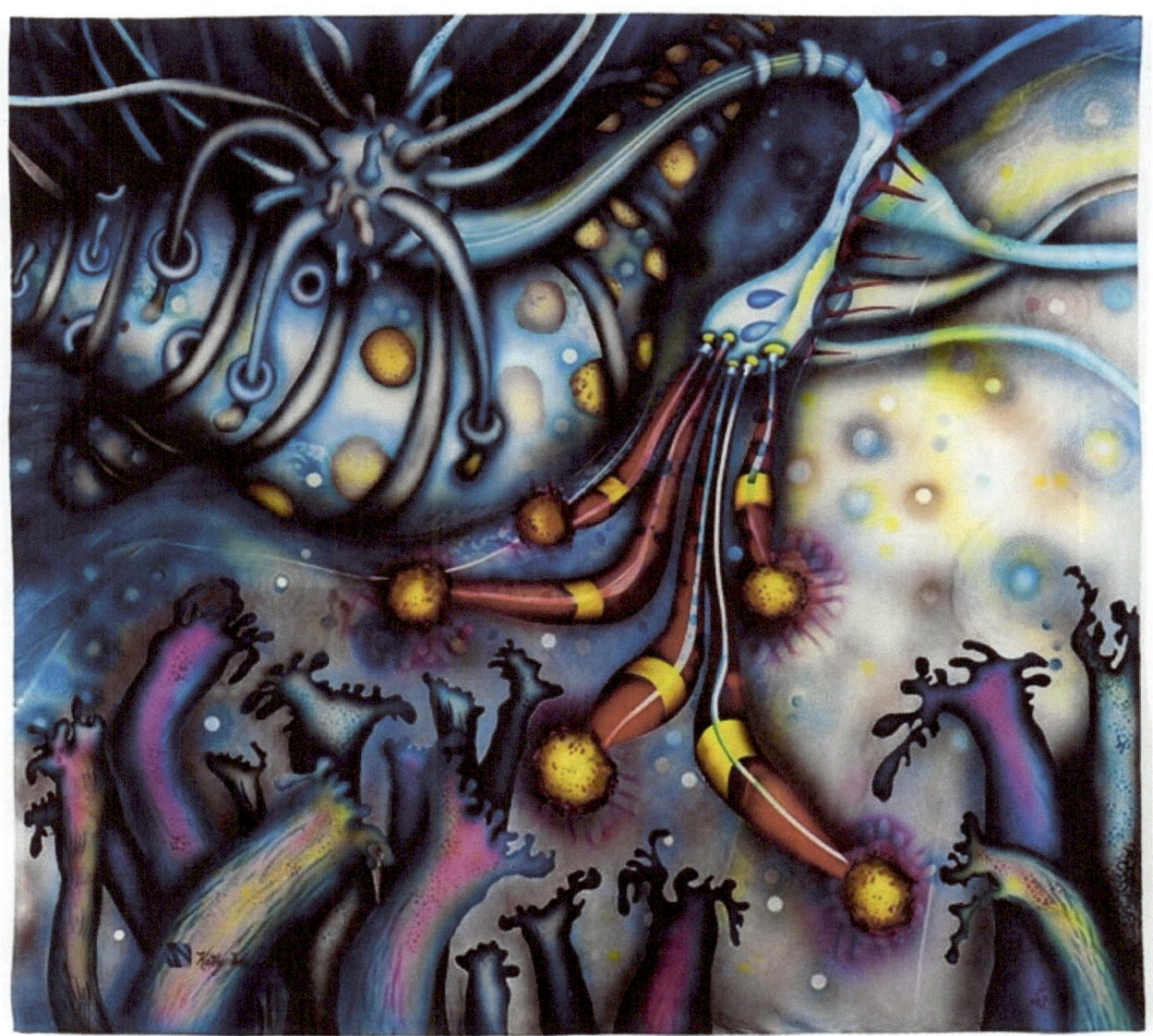

Crude Explorations 51" x 55" Satin, airbrushed, hand quilted.

Ellie Winberg

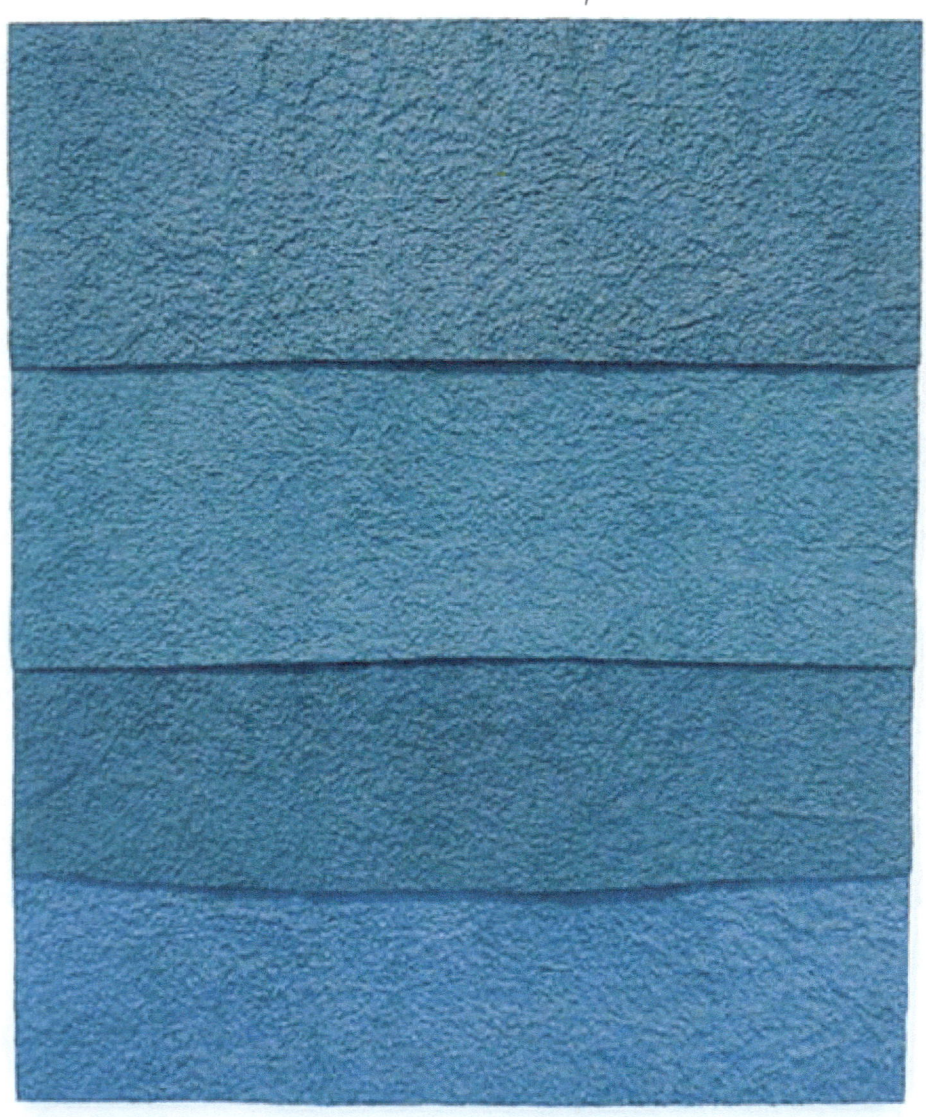

Shades of Teal 60" x 48" x 2" Handmade paper with pigments mounted on canvas.

Rachel C. Wright

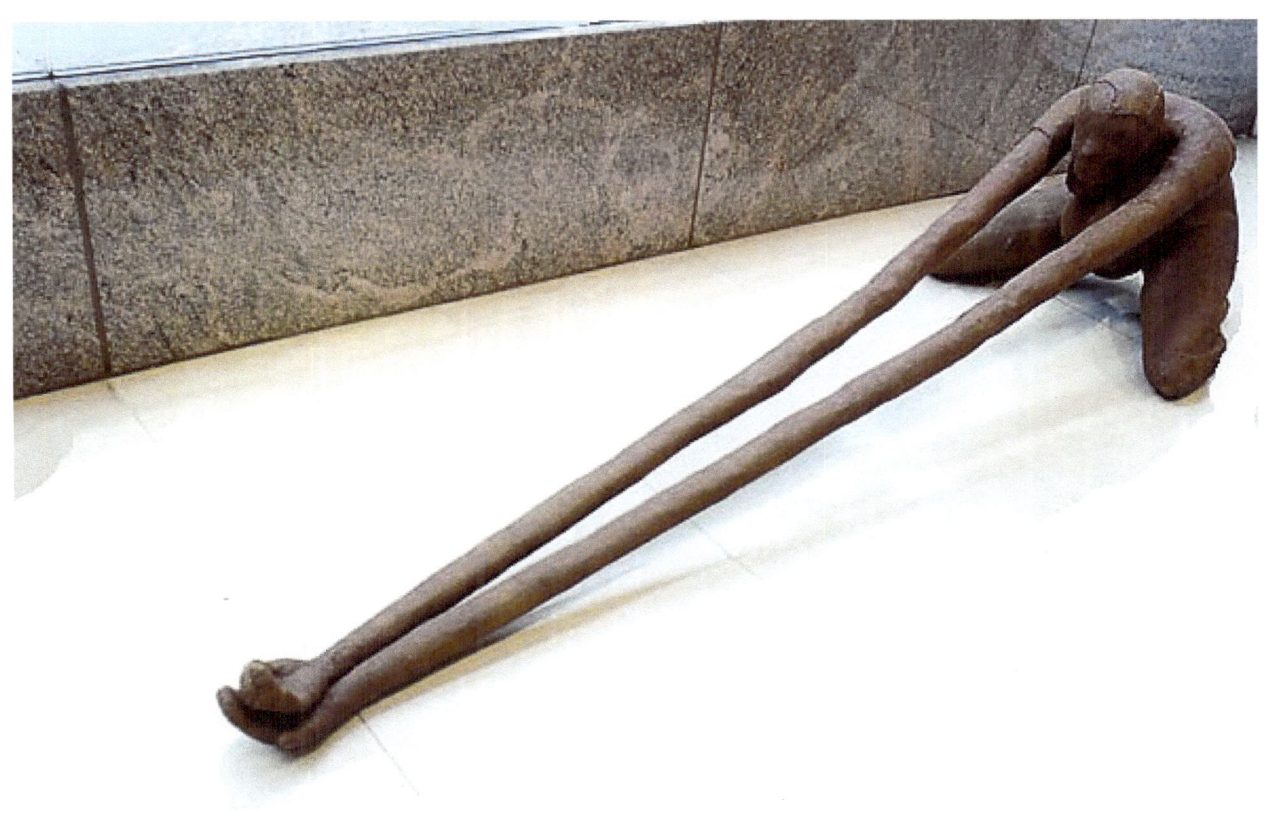

Cathartic Birth 28″ x 34″ x 117″ Burlap, amber shellac, paper, masking tape, wood.

Saaralisa Ylitalo

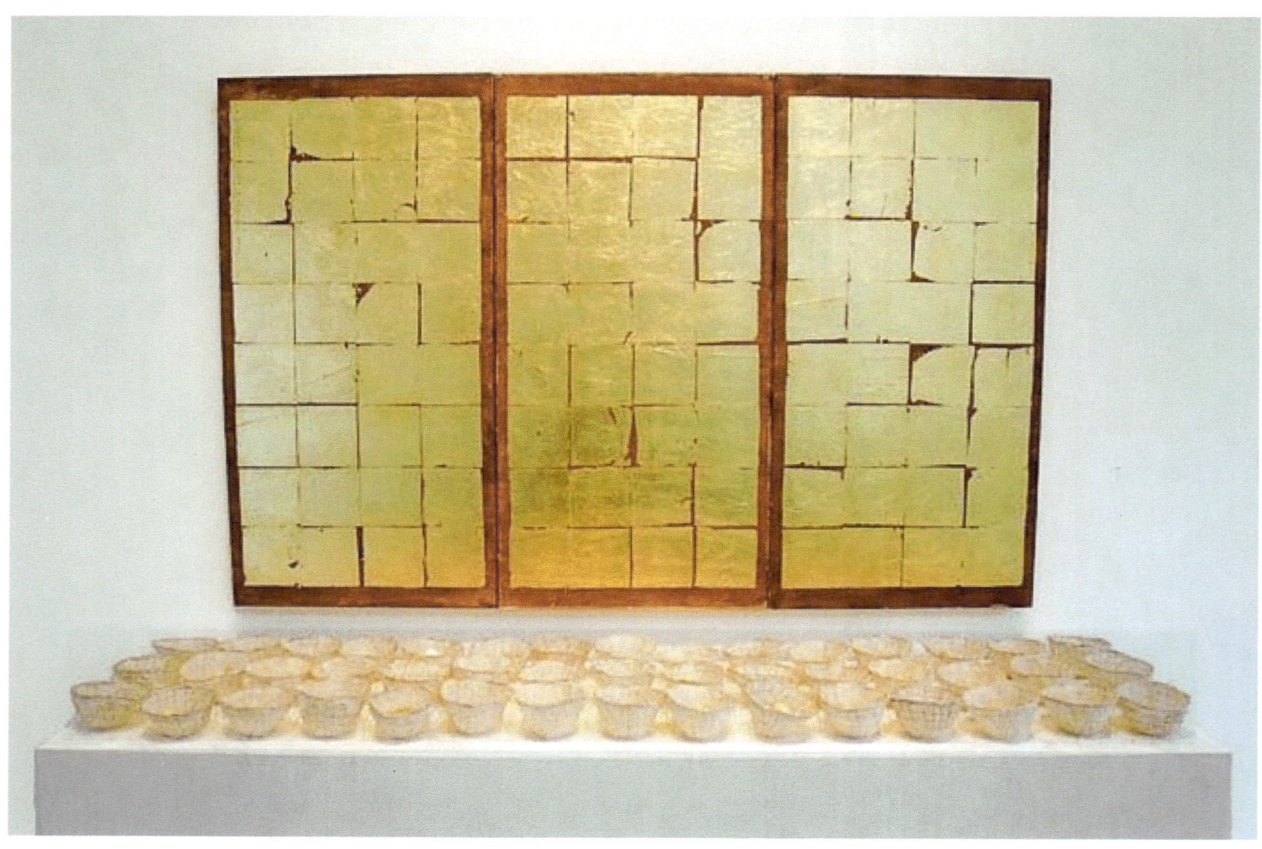

Altar and Offerings. 72" x 84" x 15". Handmade pineapple paper, gold leaf, silver and copper wire, mixed media, basketry.

Bhakti Ziek

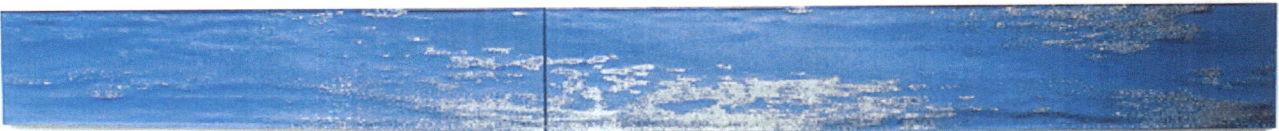

East–West. 13.5″ x 139″ x 1″. Silk, tencel, silver gimp; handwoven weft-backed Jacquard.

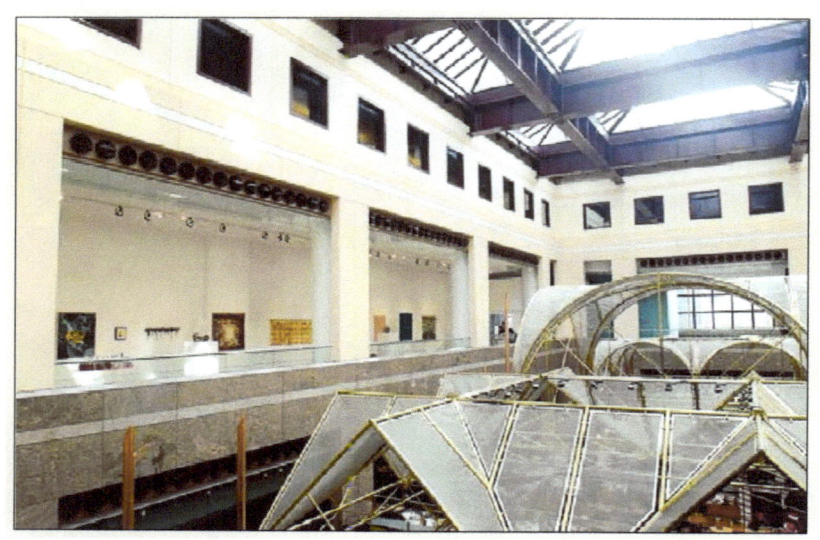

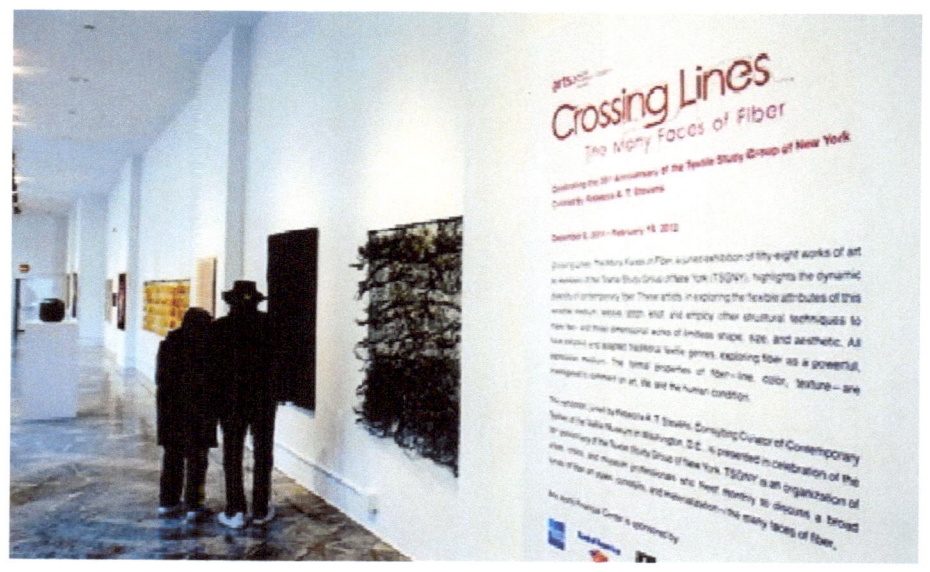

CROSSING LINES: The Many Faces of Fiber

Workers Who Made It Happen

for Textile Study Group of New York

Larry Schulte, Exhibition Chair
Charlotte Thorp, Assistant Chair
Barbara Arlen, Registrar
Katherine Knauer, Assistant Registrar
Colette Wolff, Documentation
Nancy Koenigsberg & Jody Leight, Advisors
and
Rebecca A. K. Stevens, Juror

at Brookfield Properties, World Financial Center Courtyard Gallery

Karen Kitchen, Producing Director
and her capable professional staff including
Miguel Lopez, Rebecca Zuber, Jasmine Johnson, Tom Kotik, Lily Namanworth, Tara Davis, Lindsey Power, Amanda who greeted visitors - and all the others involved in planning and accomplishing the many tasks involved in producing CROSSING LINES.

Post exhibition

Catalog design and production by Marilyn Henrion, 2017
With grateful acknowledgment to Colette Wolff for maintaining and providing the archived materials, and to members of TSGNY Board of Directors, under the leadership of Marguerite Wolfe, for recognizing the importance of documentation and enabling the print catalog to be produced.

Current Board of Directors: Marguerite Wolfe, President, Nancy Koenigsberg, Elaine Longtemps, Kim Svoboda, Marilyn Henrion, Lisa Lackey, Barbara Maxey, Emma Burzycki, Alyn Evans, Franny Logan

www.ingramcontent.com/pod-product-compliance
Lightning Source LLC
Chambersburg PA
CBHW051028180526
45172CB00002B/505